LOST
TOWNS
OF
NORTH GEORGIA

LOST
TOWNS
— OF —
NORTH GEORGIA

LISA M. RUSSELL

FOREWORD BY RAYMOND ATKINS

THE
History
PRESS

Published by The History Press
Charleston, SC
www.historypress.net

Front cover: Young girls like these were "Lunch Toters." While this photograph was taken in Columbus, Georgia, children like these could be found in the mills selling their baskets to workers. Too young to work in the mill like their older siblings, they could still make money and contribute to the family's survival. *Photograph by Lewis Hine. Courtesy Library of Congress, LC-DIG-nclc-02816.*
Back cover: This is a view of Allatoona Pass from the south. The Clayton-Mooney House *(far left)* still stands today. The railroad bed serves as the banks of Allatoona Lake. This photograph was taken after the Battle of Allatoona in 1864. *Courtesy the Atlanta History Center; insert:* Woody's Grocery Store stands in the center of what was once the first gold rush of America. Now it is a North Georgia ghost town. *Photograph by Douglas Boyle.*

First published 2016

Manufactured in the United States

ISBN 978.1.46713.651.8

Library of Congress Control Number: 2016939333

For Mimi's precious girl,
Charlotte Christine Russell.

CONTENTS

Contents

FOREWORD

I was quite excited when Lisa Russell first asked me to write the foreword for her book about the lost towns of North Georgia. The reason for my excitement was simple: I like old towns. I like the feel of them and the aura of living history that surrounds them. When I walk the downtown streets, I can sense the shuffling steps of those who came before me and hear the quiet murmurs of townsfolk long departed. I was raised in a small town in northern Alabama, an old town with a long memory. That town is as much a part of my past as my family. But that town, like so many small towns on the rural landscape, is fading away. It is half the size it was when I was a boy, and in another sixty years it will likely be gone altogether. That is the way of towns. They are born, they grow and sometimes, like their occupants, they flourish; these towns become cities. Other times, also like their human inhabitants, towns grow old, wither and fade away. It is to those towns, gone and mostly forgotten, that the author has turned her attention.

Human beings are social by necessity as well as inclination. We are individuals by birth, but alone we are not complete. We tend to seek out others of our own kind and to congregate. It is said that our earliest ancestors did this because there was safety and security in numbers, and that was no doubt true. Hungry bears and neighboring tribes would be more likely to avoid large groups and seek easier targets. But I believe that an additional reason why our forbearers gathered together was that they were seeking the psychological comfort of the group. Simply put, it is not in us to live the

solitary life. So one becomes two, and two becomes five, and five becomes many more and, eventually, a town is born.

Towns are and always have been the canvas on which the portrait of humanity is painted. They are the fabric of civilization. Towns are living entities, each unique in its own particular complexity while at the same time similar to the rest. This quote from my first novel, *The Front Porch Prophet*, illustrates the point about towns and their characteristics:

> *A thousand souls reside in the town of Sequoyah, Georgia, sixty miles southwest of Chattanooga. Located in a mountain valley, Sequoyah does not differ significantly from countless other small communities dotting the Southern landscape. It has a store and a gas station, a diner and four churches. It boasts a school, a post office, a traffic light, and a town hall. There is a doctor, a lawyer, and an Indian chief, or at least, that is what he claims. Over the years, however, the settlement has developed a character unique to itself. The whole has exceeded the sum of the parts. The individuals who have resided there have left traces, pieces of the patchworks of their lives. A child's name. A house. The lay of a fencerow. A snowball bush. This is the way of towns and of those who people them. These are the relics of security, for it is not human nature to live alone.*

Although Sequoyah is a fictional town, it is based on some of the small southern towns I have lived in and traveled to during my years on this earth. And it resembles the towns that Ms. Russell explores in this book. Sometimes there is just a name left, a piece of a building or some rusty railroad tracks, or maybe a story told by a great-grandmother that she heard as a girl, but with these pieces of the past, the author resurrects towns that once were and makes them live again.

RAYMOND ATKINS is a two-time winner of the Georgia Author of the Year. His books include *The Front Porch Prophet, Sweetwater Blues, Sorrow Wood, Camp Redemption,* and *South of the Etowah: A View from the Wrong Side of the River.*

PREFACE

Shattered and scattered on a dirt floor were remnants of an eighty-nine-year-old stained-glass window. In 2000, Cassville Baptist Church decided to remove a 1911 window that was in danger of falling out. Concerned about safety, leadership decided to remove it. Members concerned with historic preservation voiced their opposition. It was removed anyway and placed in the church barn. Leaders invited members to go to the barn and take pieces of the window, fragments of history.[1]

On a cool afternoon, my friend Darcy and I visited the old barn to find a piece of stained-glass nostalgia. Darcy was a skillful picker. She found magnificent whole pieces of glass she could display. I settled for the shards and odd broken pieces.

Not sure what to do with my salvaged slivers, I put them in a box and waited to create new art. I put the one-hundred-year-old glass on a shelf in a box. Sometimes, I would take out the box and shake the splintered pieces, wondering what I could make out of it. The debris in my box once diffused light, but these dusty pieces shed light on nothing.

I thought about those glass pieces as I began assembling the stories for *Lost Towns of North Georgia*. Piecing together history bits, I struggled to shine light on these fragmented stories. Finding clear information about the lost towns was sometimes easy and a matter of record. Other towns seemed to hide because information was scarce.

I am grateful for local authors who preserved the stories of Auraria and Cassville. The digital records left me hungry and searching for more. I

compiled digital news piles from various corners of the web about these lost towns. I unearthed shards of facts and bits of stories, shaking around fragments of history in my head. But in my head is where they stayed.

Cassville was particularly intriguing. Daily driving through the shadows of a town, I was haunted by what remained and what we do not know. It was time to look closer, dust off the box and look at the story pieces again.

These are not my stories to tell; they belong to history. I take that responsibility seriously and research with care. The task was overwhelming, but I realized that fragmented history might be lost.

Maya Angelou said, "There is no greater agony than bearing an untold story inside you."[2] Angelou was talking about people, but I believe places have a story to tell as well. The lost towns of North Georgia cry out from the red clay or watery graves, hoping someone remembers. Visiting these vanishing villages, abandonment lingers.

It is time to tell these stories again, or maybe for a first time to a new audience. So, I pulled out the collected story pieces, laid out the broken scenes and began to see a pattern. With more research, the connection between twelve North Georgia towns became clear. Each town had a season and a reason and a common theme of prosperity and poverty.

Each town had a unique purpose for a specific time. When that time and purpose was over, the town returned to the woods or crumbled into the red dirt. Fire destroyed some towns and water drowned a few. Some towns are not completely gone but are finding a new purpose.

Come look through broken pieces of lost history. Find an interesting colored piece and envision a place as it once was. Imagine for a moment what these places meant to the people who lived there. We learn from the past to realize the future.

Take a trip with me to the *Lost Towns of North Georgia*.

ACKNOWLEDGEMENTS

I am a Georgian by choice, not by birth. I have lived longer in Georgia than I ever lived in my birthplace—Buffalo, New York. I will always feel kinship with western New York State, but my life started in North Georgia. I have red clay under my skin and "ya'll" planted on my lips. It is here that I found my life—my family and my God. I thank them all.

My oldest son, John, loves digging history as much as I do. If he were not a worship minister, he would be a great researcher lost in an archive somewhere. You are a good man, husband and father. My middle son, Mike, is a tenderhearted, hardworking man who will be there for me when I need him most. I do love my middle son—I was a middle child and understand. My youngest, Samuel, has a good mind and I enjoy his intellectual companionship. We share so many things, like talking about politics and academics. Samuel, as a teenager, would taunt me, saying that I was not a real writer because I did not have my name on a book cover. One question, Sam: "Am I a *real writer* now?" To my long-suffering husband of over three decades, John David Russell, I look forward to building our new nest with my own room to write.

I love my sons, but God knew I needed a daughter. So far, God has given me two wonderful daughters-in-love: Laura Leigh and Becka Brea. I am no longer outnumbered. Thank you, Laura Leigh, for not only the editing but also the gift of my favorite girl, Charlotte. I hope you continue to love books because this book is for you.

I have a chosen sister and a real sister. Ella Landrum has tried to convince me for years that I was a writer. Ella has stuck around longer than any friend, and I am grateful for her mercy. My real sister has also encouraged me to do what I love—to teach and to write. Through our mutual broken road, God blessed Ellen and me; we found our way back to each other and found healing for our fractured past.

The people you work with become your other family. My colleagues and friends at GNTC and KSU have made a difference in my life. Thank you to the best dean, Dr. Jodie Vangrov. To my office neighbor and friend, Dr. Jan Lanier, thanks for all the free therapy. Stephanie Kinman is my spiritual reminder. To Tom Bojo and Anu Moorthy, thank you for the resources to jump-start my research and for your passion for history.

I am indebted to my graduate professors at Kennesaw State University. To be more specific, I thank Dr. Mary Lou Odom for helping me believe that I am a writer. To Dr. Laura McGrath, your respect and interest in me created another writing teacher. I was so excited when I could just call you "Laura" and am now blessed to call you "friend."

One thing is true about writing your first book: it starts a chain reaction. I cannot wait to start the next one. David and Shannon Byers of Timeless Paranormal have added a new dimension to this story. I look forward to our next adventure, but this time with a better GPS. I share a love for local history with Michael Garland. Mike, you have everything we need to write two more books. I am ready. Are you?

Finally, teaching college can drain your energy, but it can also be invigorating. To my students, every morning you inspire me to get up and do it all over again.

My appreciation goes to the following persons and institutions: Tina Shadden and Sandy Moore, Bartow History Museum; Joe Head and Linda Cochran, Etowah Valley Historical Society; Bonnie Willis, Arlene Whybark and Dale Black, Cassville Historical Society; David Gomez, New Echota Historical Site; Russel McClanahan, Rome History Museum; Rabun County Historical Society; Lumpkin County Historical Museum; Dahlonega Gold Museum; Georgia Archives and Vanishing Georgia Digital Collection; and the following artists and photographers: Douglas Boyle, Urban Baboon.com; Christopher Muller, SteamPhotos.com; Jodeen Brown, Historical Artist Bartow County; and Ray Atkins, for your well-crafted foreword to this book.

INTRODUCTION

North Georgia did not belong to Georgians. They stole it. One tie that binds these towns is their relationship with the Native Americans who lived and reigned in this area. The Cherokees and the Creeks were swindled out of mineral-rich land. Almost every one of these towns began as ill-gotten gains and in collusion with federal and state authorities.

When gold was discovered in North Georgia years before the California Gold Rush, the State of Georgia took action to acquire the land. It wanted the gold in Auraria, Etowah and Cassville. It wanted the waterpower in Scull Shoals, and it wanted the iron ore in Estelle and Etowah. It wanted the rich land in Cassville and Calhoun near the Cherokee Nation's capital at New Echota. Georgians wanted Cherokee land and would do what it took to get it.

The federal government conspired with Georgia officials, and the Cherokee and Creeks were removed from Georgia by 1838. Only a few, who renounced their citizenship to the Cherokee Nation, were allowed to stay. In criminal investigations, a strategic move is to follow the money. The money in North Georgia was the land, the rich minerals and the gold. In every lost town story, some wealth was the issue. Most towns died due to an underlying sickness: greed and shortsightedness.

Author e.e. cummings wrote, "Always the beautiful answer who asks a more beautiful question."[3] While investigating towns, asking the right questions produced unexpected answers. First asking "Why?" will take you to many remarkable places. With purposeful intent, an attempt was made by the author to answer the "why?" question. But learning about these lost

towns only brought more questions. This book is not intended to be the end-all for every lost community in North Georgia. A truth uncovered was: the more you learn, the more you want to learn and the more there is to learn.

There are towns that are still being discovered. The Etowah Valley Historical Society has uncovered new communities previously unknown under Lake Allatoona. Abernathysville, Gladeville and Macedonia are listed on the society's maps, but more research is needed to uncover details. Many towns remain on private property, and tourism is not encouraged. Many forgotten communities have so little information available that they may be lost forever to history. Towns like these are not overlooked, but require more investigation.

RE-CREATING HISTORY

The hope is to bring dead towns to life. The attempt was to tell these stories in the creative nonfiction style. This is not a novel, but portions of these stories were re-created from images and descriptions of the people, places and things found in archival documents. No attempt was made to contrive or deceive. It was an artful endeavor to engage the reader.

This book contains two pieces of art by Jodeen Brown. Ms. Brown is a talented artist who researches before she paints. She re-creates places that no longer exist. The Cassville Female College painting in this book was reconstructed from a tiny 1850s wax seal on a diploma. No other image of this building exists. The Cassville Courthouse pen-and-ink drawing in this book was reconstructed by Brown from historical descriptions of that era. No images remain—everything was burned by Sherman's troops. As with Jodeen Brown's historical art, some parts of this book were written by the author to paint a picture, to reconstruct the facts. Attempts to add color to these stories were based on facts and scholarly research.

PART I
ANCIENT TOWNS

1.

CASSVILLE, BARTOW COUNTY

A pleasant place to live, and an element of culture and refinement was apparent.[4]

In one final rebellion, the crisp autumn day turned dark. A foreboding sky brought cold rainfall on Cassville as Federal smoke rose from the smoldering remains. It was November 5, 1864.

At ninety years old, J.L. Milhollin remembers the day with perfect clarity. He was a fourteen-year-old boy; his father had died in July. J.L.'s father, John F. Milhollin, served as clerk of the inferior court from 1855 until he enlisted in the Confederate army in 1861. Killed in Virginia, his body was returned to Cassville in the summer of 1864. His wife and children lived across from the cemetery. When the order came to destroy Cassville, the Milhollin family lost their home just like their neighbors. The young Milhollin son covered his father's grave with salvaged wood planks. He then fashioned a rough tent frame with a quilt attached to a fence and his father's headstone. The Milhollin family spent the night on top of the grave. J.L. was the man of the family now, and he took responsibility. The next morning the young Milhollin found a slave cabin four miles away and moved in with their remnant belongings.[5]

Many families had evacuated long before this terrible day. Many left before the May 19, 1864 battle. Sally May Akin escaped with her husband, Confederate congressman Warren Akin, before the Union army came to North Georgia. Akin would have been sent to a Northern prisoner-of-war camp. The Akins escaped to Oxford, Georgia, to live as refugees.[6]

Refugees leaving Cassville toward Atlanta found that food was scarce and expensive. A turkey, if it could be found, was seventy-five dollars. Bacon was twenty-five dollars per pound, and a small package of needles for mending cost fifteen dollars.[7]

When the war was over, the Akins came back to Bartow (formerly Cass) County, but not to Cassville. Like many others, they moved to the new county seat in Cartersville. The family began a law practice in Cartersville near the train depot. That same practice remains open to this day and is run by Akin descendants.[8]

Not everyone left Cassville before November 5, 1864. Many women were war widows and had nowhere else to go. Huddled with their children, women refugees suffered through a sleeting day and watched their homes burn to the ground. Some returned to rebuild; some found homes elsewhere. Most never returned.[9]

Today, Cassville is a three-way stop to somewhere else. Once the largest city in northwest Georgia, 1840s Cassville was an educational and cultural center.[10] According to the Etowah Valley Historical Society:

> By 1849, Cassville was the largest and most prosperous town in northwest Georgia. Letters addressed to Rome, Georgia, were directed "via Cassville." There were 4 hotels: Brown & Dyer, kept by Higgs; Cassville Hotel, kept by John Terrell; Eagle Hotel, kept by Aaron Burris; and the Latimer Hotel, kept by William Latimer. Leading merchants were George S. Black, T.A. Sullivan & John A. Erwin, J.D. Carpenter, Fain & Smith, Sam Levy, John W. Burke, Patton & Chunn, Humphrey W. Cobb, and George Upshaw. There was a Baptist, Methodist, Presbyterian and an Episcopal church.[11]

The town was home to doctors, lawyers and entrepreneurs. Cassville was a bustling, brick-paved town filled with business, education and culture. By 1864, Cassville was lost. The promising thirty-two-year-old town went up in smoke, first when it missed the train and, later, when Federal fires leveled the town.

County Seat

In 1832 the Georgia legislature concurrently created Cassville and Cass County (now Bartow), making Cassville the county seat. Cass County was

carved from former Cherokee territory. Gold prospectors invaded sovereign Cherokee land that was once off-limits to white Georgians. This early gold rush would lead to the desolation of the sovereign Cherokee Nation and to the Trail of Tears (see chapter 2).[12]

Cassville was a promising development centrally located in the Cherokee section. It became the legal center. Many barristers in the Cherokee Circuit

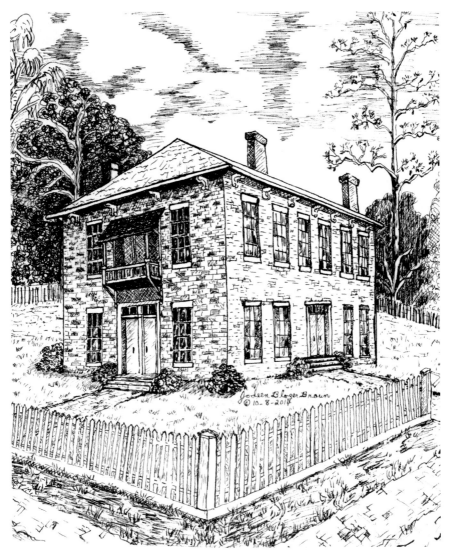

Local artist Jodeen Brown researched antebellum courthouses and reconstructed this pen-and-ink sketch of Cassville's historic courthouse. *Ink sketch by Jodeen Brown.*

maintained offices in Cassville. By 1833 the town had judges, lawyers, commissioners and a senator.[13]

Within ten years of its birth, Cassville was growing. By 1836, forty homes occupied the city limits, with more farms outside of town. A brick kiln was the first manufacturer, supplying the construction boom of community buildings. The jail, the academy and the courthouse used the locally made bricks.

The courthouse was the most impressive building in Cassville. It cost $9,000 to build this two-story structure in 1836. The pen-and-ink image by local artist Jodeen Brown was re-created from this passage in Joseph B. Mahan's book *A History of Old Cassville: 1833–1864*:

> *This was a rectangular, two-story structure with large double doors opening on each of the four sides. Most of the lower floor was given over to a courtroom with small vestibules inside the doors. Steps leading to several offices on the second floor were located in the vestibules at the ends of the building. In 1837 Adiel Sherwood in his Gazetteer termed this courthouse to be "one of the most elegant in the state."*[14]

THE RAILROAD SITUATION

When Western & Atlantic Railroad laid track through northwest Georgia in the 1840s, the route excluded Cassville. The closest access to the railroad would be two miles down the road at Cass Station. Several theories have existed as to why tracks never ran through the largest town in the region.

There is evidence that residents did not want the evil train coming through the young town. As in many towns of this era, the people did not want the railroad to change the character of their town. The only evidence that Cassville's residents refused to allow the tracks to come through town were newspaper accounts that suggested the route was changed and that the citizenry celebrated because Cassville was not "contaminated by the vile railroad." A local newspaper reported that they did not want the dirt, smoke and whistles disturbing students and "hard working newsmen." This rhetoric may have been an attempt to make the best of an inevitable situation. The combination of geology and geography was the most likely reason.

This region in northwestern Georgia is a geologist's playground. The area between Adairsville and Cassville in Cass County had a gravel plateau that

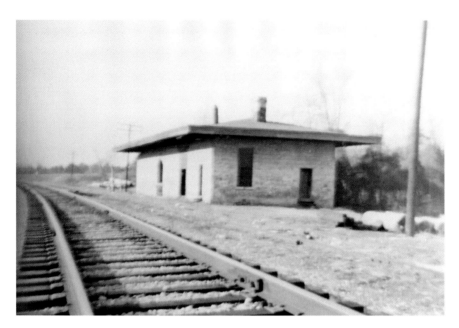

Cass Station, two miles from Cassville, was one of the reasons Cassville never rebuilt after the Civil War. The railroad never ran through it. *Courtesy the Atlanta History Center.*

would have made laying tracks to Cassville expensive and difficult. There is evidence that town leaders knew the value of the railroad coming to town and tried to make it happen.

Whether it was the geography or the attitude of the town, the train never came closer than two miles to 1840s Cassville. The hotels lost vacancies, and business was down. Perhaps that explains an 1857 "Why go elsewhere?" advertisement in the *Standard*:

> *If you want to buy dry Goods, you will find Carpenter and Compton, G.L. Upshaw and Sam Kevy all with full stocks and anxious to sell, at fair prices.*
>
> *If you want Family Groceries, go to McMurray's and Brown's where you can get anything in that line—even a little of the "juice."*
>
> *If you want a buggy or carriage made, call on Holmes, Headden, or Nelson.*
>
> *If you want any blacksmithing done, go to the Headden's, Holmes' or Upshaw's.*
>
> *Want a Saddle? Go to Brown's and have one made, any kind you may wish.*
>
> *Anyone Sick? We have Kinabew, Griffin, Hardy, and Groves, all of them experiences in their profession.*[15]

Cassville, despite the loss of the railroad, still had a great deal to offer. The citizens realized they needed to adapt to the changes. If Cassville could no longer be the center of commerce, it would be the cultural and educational center of North Georgia.

CULTURAL CENTER

Cassville was a young town populated with young people, as reported by a local newspaper: "A pleasant place to live, and an element of culture and refinement was apparent."[16] Most early citizens were in their twenties and thirties. They wanted to offer education and culture to the North Georgia area. Cassville wanted to become the cultural center, even as it was losing economic supremacy due to the railroad situation.

It was losing business as the railroad went to Cass Station and Cartersville. The hotels lost their monopoly and small businesses suffered from shipping issues, but Cassville adapted. In 1845, the same year the Cass Station was completed, the Thespian Society was organized two miles away. It was intended that young men would study and perform drama for public entertainment in the brick academy. The group's first performances were two comedic productions, *The Lottery Ticket* and *Family Jars*. As usual for the times, men played all the parts.[17]

NOT ONE BUT TWO COLLEGES

The ambitious town decided to begin two colleges, to be run by other organizations but operating under a board of trustees made up of Cassville residents. Both colleges were established in 1852. Cassville Female College began classes in 1854, but the men's college had a slower start. Cherokee Baptist College was set to open in February 1856, but one night in January a fire destroyed the building. The college still opened, and classes were held in private homes until the school was rebuilt.

Sarah Joyce Hooper was the first graduate of the women's college—the first and only graduate in 1855. Wyley M. Dyer of LaFayette, Georgia, was awarded a bachelor of philosophy degree (BPh) on July 14, 1857. He was the first and only graduate that year from the men's college.[18]

Cassville Female College and Cherokee Baptist College coexisted. Some gossips commented about the boys taking the long way around town to return to their college, having to pass the women's college. Some things never change.

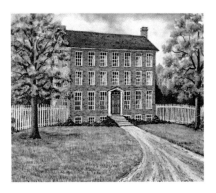

The colleges were closed in 1863 as war approached North Georgia. Records show that Cassville Female College became a place for both sides to ravage and occupy. Snipers killed ten Union soldiers and threw nine on the female college grounds, where the Federals were billeted. Anger against

Cassville was a college town with two four-year colleges. Local artist Jodeen Brown painted Cassville Female College from a diploma seal. *Painting by Jodeen Brown.*

the town intensified. On the next day, October 11, 1864, both colleges and several private homes were burned.[19]

Local historical artist Jodeen Brown studied an ancient wax seal that once held together a rolled diploma from the Cassville Female College. Using a magnifying glass, the tiny seal revealed the only remaining college image. Brown studied the seal and recreated the school sitting peacefully on College Hill before its destruction in fall 1864.[20]

DIRTY LITTLE SECRETS

Cassville was a young town seeking significance by reaching higher, but it was still the antebellum South. The local newspaper exposed the darker aspects that existed in even cultured and educated Cassville. The *Standard* announced this county sale:

> *Cass Sheriff's Sales for March 1859*
> *On the first Tuesday in March next, within the legal hours of sale, before the courthouse door in the town of Cassville, the following property will be sold* [Only slave sales transcribed]*:*
>
> *Two negroes—Bill, 45 years old, and Green, 17 years old; property of John M. Dobbs; fi fas in favor of Courtney & Tenant, and others.*
>
> *Also, one negro woman, Maria; property of Wm. P. Hammond; fi fas in favor of Wiley, Banks & Co., and others.*

Also, one negro woman, about 28 years old, and her two children, 7 and 9 years old; property of James R. McNeese; fi fa in favor of A. Worley & S.M. Bailey.

Also, one negro boy, George, 26 years old; one negro woman, Gincy, 30 years old—property of John W. Clayton; also 40 bags of cotton, more or less, one negro boy, John, 25 years old—property of Stephen Glazener; fi fa in favor of Caldwell, Blakely & Co.

Also, a negro man by the name of George, 30 or 35 years of age, and one negro man by the name of Phillip, 50 or 55 years of age; also a remnant of dry goods, consisting of many articles too tedious to mention—property of J.D. Terrell; fi fas in favor of Force Conly and others.

Also, one negro man by the name of Spencer, 50 or 55 years old—property of Alison Nelson, fi fa in favor of M. Whitfield.[21]

More disquieting than the very fact of this listing is that this was not the only such announcement in the local newspaper. This historical reflection of human trafficking on the courthouse steps still repulses, but it's a lesson to remember.

Cassville Burning

The residents of Cass County and Cassville needed a change. In 1861 the name of their county and town no longer felt appropriate. Cass was originally named after an abolitionist Yankee from Michigan and President Jackson's secretary of war, General Lewis Cass. In defiance, the general assembly on December 6, 1861, renamed the county Bartow to honor Colonel Francis Bartow, who fought in the First Battle of Manassas (Bull Run).[22] Cass County became Bartow County, and Cassville was renamed Manassas. The county name stuck, but the Federal Post Office never recognized the town of Manassas. Bartow residents were rebellious and ready for a fight. Some historians suggest that the name change infuriated Federals, but this may have only been kindling for the fire that was coming.

Guerrilla warfare was prevalent near Cassville. Confederate tactics infuriated Federal officers. Union general William T. Sherman devastated the Georgia countryside during his march to the sea in 1864. His men destroyed all sources of food and forage, often in retaliation for the activities of local Confederate guerrillas. Sherman employed a policy of punishing civilians for guerrilla activity. If guerrillas or bushwhackers struck at Union forces or

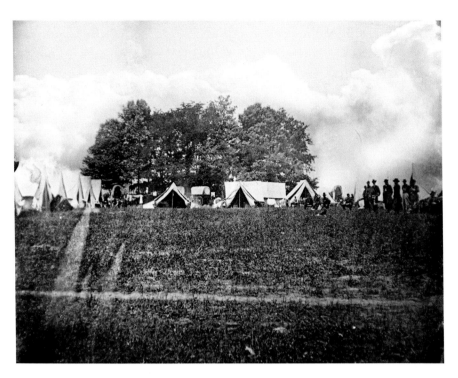

Headquarters of General George H. Thomas, near Cassville, Georgia, May 21, 1864. The Army of the Cumberland was part of the Atlanta campaign. *Courtesy LOC, LC-DIG-ppmsca-33005.*

attempted to impede their march by destroying bridges and obstructing roads, Sherman often ordered the destruction of houses in the vicinity. Some of the harshest reprisals for the attacks of guerrillas and Confederate cavalry scouts took place a few days earlier, when Union troops burned much of the town of Cassville and portions of other towns in Northwest Georgia.[23] While the county name change was insulting and the guerrilla tactics were incendiary, the destruction of Cassville was not entirely reactionary. There was a plan.

During the Atlanta campaign, Confederate general Joe Johnston intended a major offensive in the prosperous town. He tricked General Sherman into dividing his forces at Adairsville. The planned offensive would have been successful at leveling the playing field for the extremely outnumbered Confederate troops. However, the evening before the battle, planned for May 18, 1864, Confederate general John Hood convinced Johnston to withdraw south to another location. Union forces occupied Cassville from that night until November 1864. While Johntson retreated from his initial plans, the women and children were advised to evacuate.[24]

On October 30, orders were issued to destroy Cassville. Residents were given only twenty minutes' notice, and the town was burned so completely that no images or official records of its citizens survived. No other town in Georgia was as effectively destroyed during Sherman's march to the sea. Yet, from the charred remnants, undefeated townspeople hung on to life. An interesting note was that Sherman was infuriated by the guerrillas; he gave the orders to burn Cassville on November 8, three days after the deed had been done. Maybe Sherman could not or did not want the record to show that his subordinates carried out such an action without his knowledge.[25]

Everything was destroyed on November 5, 1864. The Fifth Cavalry of Ohio spared a few structures, including three churches and the doctor's home that served as the hospital. Everything else was destroyed, including the colleges, the schools, the businesses and the courthouse. Cassville, Georgia, was lost.

CASSVILLE LOST TO CARTERSVILLE

When the smoke cleared after the burning of Cassville, there seemed no reason or money to rebuild the colleges, hotels, homes and businesses. A bustling new town to the south, Cartersville, was growing because the railroad ran through it.

In 1867 the people of Bartow County voted, and Cartersville beat Cass Station by a narrow margin—the county seat was moved from Cassville to Cartersville.

Today, the town's narrative resides in a few books filled with sparse archival information and handed-down stories. The roadside historical markers leave gaps in the story. A lone stone pile memorializes the county courthouse where Cherokee legal battles were fought and lost. The old Cassville Post Office reminds citizens that mail is no longer delivered to Cassville addresses. The state made Cassville disappear by removing it from the official maps when the town was unincorporated in 1995.

THE REMAINS

A short drive down Cass-White Road (exit 296 on Interstate 75 between Adairsville and White) ends at a three-way stop, the heart of old Cassville. Along the way one passes an antebellum house, the Hardy-Watkins

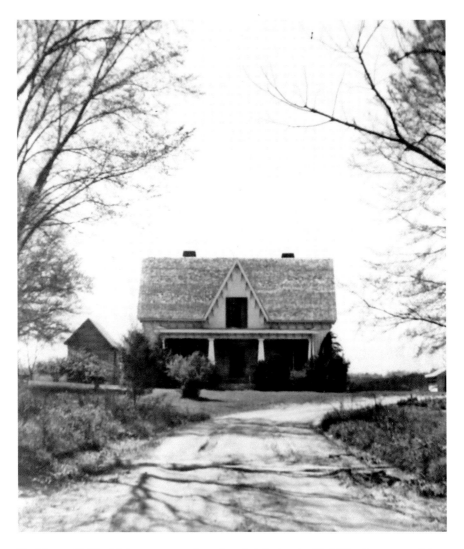

Dr. Weston C. Hardy's house was used as a hospital during the Civil War. It was one of the three Cassville buildings spared by Federal troops. *Courtesy Cassville Historical Society.*

Home, built around 1850. Dr. Weston C. Hardy's home was spared by Union troops because it was being used as a hospital. This private home is not open to the public, but the stories surrounding it are fascinating. Legend has it that there are Minié-ball holes in the wall and a bloodstain that refuses to be ignored. A bloodstain on the stairwell keeps bleeding through the pain. Two stories prevail. One is that a Yankee soldier was shot on that landing; the other is that a Confederate soldier tried to write

Cassville Methodist Church, founded in 1836, had a balcony for slaves. The log building was spared the Union torch, but it later burned and was rebuilt. The original log foundation remains. *From the author's collection.*

on the wall with the stump after his hand was amputated.[26] This was one of the six surviving structures.

The Cassville Methodist Church was burned during the war, and the present church was rebuilt on the original foundation. One of the giant logs

of the foundation carries a hole left by a Yankee shell. Handmade bricks were also used in the building.[27]

The Cassville Baptist sanctuary, dedicated in 1911, was not in fact the oldest. According to church records, Beulah Baptist Church (the original name of the church) was established in 1832 just outside the city limits. The church moved to the south side of town in 1838 and was renamed in 1847.[28]

During the Civil War, Union soldiers debased the church building. The 1866 Baptist Association reports, "The church building was used as a barn by federal troops, and the pews were overturned and used as horse troughs to feed grain to the horses."[29]

The antebellum Presbyterian church was built in 1844 as the Cassville Presbyterian Church. The Presbyterians dissolved in 1872 and gave the building to the black families living in Cassville. What remains is the New England Barn home with a sloping roof and a wood truss. Following the Battle of Chickamauga, casualties came to this church for treatment.[30] This original building sits alone, slanted with age on a precipice on Cassville Road. The building, in disrepair, stands as a stark reminder of a lost time.

When the soldiers went through the town, they spared three residences: the doctor's home, the tailor's home and a residence housing a sick older woman. Dr. Hardy's home served as a hospital. The home of the tailor, A.C. Day, reportedly had a Masonic emblem—an officer spied this and spared the home. The mother of prominent citizen and war hero General William T. Wofford lay ill, and the fires passed by the house.[31]

The Cassville Confederate Cemetery, formerly the old Cassville town cemetery, remains, with the addition of three hundred stones for unknown Confederate soldiers. The stones stand guard on a slight hill. This same graveyard provided refuge for the Milhollin family on the night their home burned.

A few federal and state markers remind us of the lost places in town. Monuments beg for visitors to see the significance of a lonely town that has seen better days. While it is hard to picture the bustle of a large town with colleges and culture, it is impossible to imagine that same town burned to the ground.

The lost town of Cassville is remembered each year when the Cassville Historical Society has a ceremony to place luminaries among the graves in the Confederate Cemetery. Townspeople dress in period clothing, and a Civil War reenactor sets off a cannon salute to the unknowns on Confederate Memorial Day. In the fall, the historical society tells about Old Cassville while offering historical tours of remaining structures.[32]

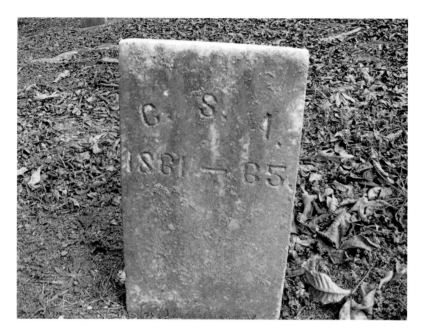

The Cassville Historical Society honors each anonymous Confederate grave in the Cassville Cemetery on special days throughout the year. *From the author's collection.*

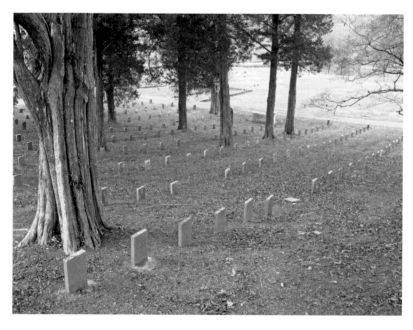

In May 1899, the Cassville Chapter of the United Daughters of the Confederacy placed headstones for three hundred unknown Confederate soldiers in the Cassville Cemetery. *From the author's collection.*

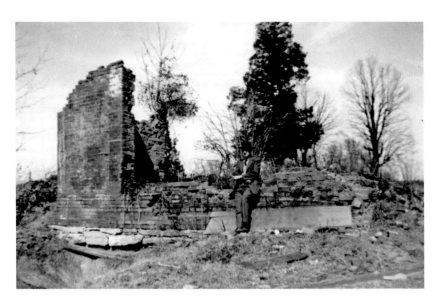

Wilbur G. Kurtz (1882–1967) photographed crumbling towns in North Georgia. Kurtz is sitting on this old building near Cassville. *Courtesy the Atlanta History Center.*

W.D. "Darby" Fowler in front of Cass Grocery, which has been around since 1887. It stands on the corner of Old Highway 41 and Cass-White Road in Cassville. *Courtesy Cassville Historical Society.*

Cassville remains in the shadows. Its story is one of history's great mysteries—a tale seldom told and dying with those who passed it down. The historical society makes a heroic attempt to keep the town alive, but Cassville remains a victim of the Civil War and a change in fortune.

Trying to understand why towns like Cassville get lost in history can cause circular thinking. Perhaps King Solomon had the answer years ago:

> *There is a time for everything, and a season for every activity under the heavens:*
> *a time to be born and a time to die,*
> *a time to plant and a time to uproot,*
> *a time to search and a time to give up,*
> *a time to keep and a time to throw away,*
> *a time to tear and a time to mend.*[33]

Maybe—it was just time.

2.

NEW ECHOTA, GORDON COUNTY

I can feel his [my father's] *anger and frustration. There is nothing he can do. From my mother I feel fear. I am filled with fear, too. What is going on? I was just playing, but now my family and my friends' families are gathered together and told to walk at the point of a bayonet.*

—*Samuel Cloud*

They pounded so hard; the door nearly came off its hinges. Soldiers, foreign soldiers, burst in the house with rifles drawn and pointed them at the children. The soldiers were yelling, "You had two years! You made your choice! Now, get up! Let's go!" The family were allowed to take the clothes on their backs and little else. They were forced into a fenced stockade, herded like cattle.

The family stayed there for months with no shelter above and red clay as a bed. They stayed penned up with many other families in close quarters, and they were left exposed to sickness and disease. Some two thousand Cherokees died in the stockades. This hell was Fort Wool, located in New Echota. Thus began the "Trail Where We Cried" or, as we know it today, the "Trail of Tears."[34]

When it was finally time to travel, the weather had turned cold. The year 1838 brought a harsh winter down on the Cherokees. Supplies of dried corn and salt pork ran low, and few people along the way offered help, while others took advantage and charged inflated prices for grain. The Mississippi River was frozen. Many groups were trapped between the Mississippi and

another river frozen behind them. They could no longer move forward; they were stuck for weeks in ice and snow.[35]

Many spots were impassable, but the Cherokees were pushed by gunpoint to a new land west of the Mississippi. Eventually fifteen thousand Cherokees, mostly on foot, made the seven-hundred- to eight-hundred-mile journey, which averaged 120 days. Over four thousand would never see their new home.[36] New Echota, the Cherokee capital, was lost to history.

Samuel Cloud was nine years old when he made this journey. His father had already died:

> *We walk across the frozen earth. Nothing seems right anymore. The cold seeps through my clothes. I wish I had my blanket. I remember last winter I had a blanket, when I was warm. I don't feel like I'll ever be warm again. I remember my father's smile. It seems like so long ago.*[37]

Imagine this happening today. A foreign government taking you and your family away from the only land you have ever known. Wouldn't you feel betrayed? Your political leaders signed away your home and property to a hostile enemy. Impossible! But it happened in 1836, when Congress passed a treaty to remove the Indians from Cherokee land in North Georgia. President Andrew Jackson signed it into law; the Cherokees had two years to get off the land. The worst part was that the Treaty of New Echota was signed by three of their own: Elias Boudinot (1804–1839), Major John Ridge (1771–1839) and John Ridge (1802–1839). These men later paid a high price for their betrayal.[38]

ASSIMILATION

At the end of the American Revolution, the United States initiated a "civilization" policy, funding missionary groups to go among the tribes and "Americanize" the Cherokees, Choctaws, Seminoles, Chickasaws and Creeks.[39] The young government promised Native Americans that if they could become more "white" like their neighbors, they would become social and political equals. Thomas Jefferson even commented that, someday, the Indians might be equal to whites.

Cherokees owned most of North Georgia. The Cherokee Nation was a sovereign country, but its members knew that fighting the whites would not

end successfully. After all, it had not worked for the Creek Indians. They decided to continue assimilation as a means to be accepted and to protect their way of life.

Cherokees were encouraged to grow wheat instead of corn and to have regular meal times. They were taught how to dress in English clothing and speak the English language. They changed their names to common Anglo names. They went to mission schools, and the wealthy sent their children to northern schools. The Cherokees were indoctrinated into Christianity.[40] The Cherokees and leaders like Elias Boudinot encouraged acculturation, a strategy to assimilate Anglo-Saxon ways for acceptance into society. Their hope was that the government would leave them alone. In the process, they created their own constitution, government, capital and a new language.

The leaders established the Cherokee Nation capital in New Echota. In 1827, they wrote a constitution with two preambles, like that of the United States. In addition, they created a court and a meetinghouse. John Ross was appointed their principal chief, the equivalent to president. The Cherokees set up "eight judicial districts and a bicameral congress. All of this for a population of about 20,000 people living in an area a fraction of the size of Georgia."[41]

A Cherokee named Sequoyah never learned to speak, read or write the English language, but in 1821 he invented a Cherokee syllabary with eighty-six characters. His language system is similar to Chinese, in that a symbol exists for every word. He worked on it for years and neglected his crops. His neighbors called him insane, and his wife burned his work. She thought it was witchcraft or sorcery. Many Cherokees did not see the point. Despite the roadblocks, by 1825 it was in general use, and the Cherokees were more literate than their Georgia mountain neighbors.

Boudinot traveled and spoke in order to raise money for the Cherokee Nation. Monies from his writing allowed him to purchase a printing press, and the first Indian newspaper was created. The *Phoenix* was written in both English and the Cherokee language. When Boudinot returned home, he helped Sequoyah by editing the newspaper. He also translated the New Testament for publication on the front page.[42]

All of this assimilation and acculturation was in vain, however. Georgians did not care how civilized the Cherokees became—they wanted them out. And they wanted their land—all of it.

THERE'S GOLD IN THAT CHEROKEE LAND

The first gold rush was not out West, but in North Georgia. Auraria, a little town near Dahlonega[13] in Lumpkin County, was rich in gold—flakes were lying on the cut ridges in the red clay. Auraria, in the middle of sovereign Cherokee land, found itself at the center of a gold rush. The Georgia government was impatient with the federal government's promise to remove the Cherokees from North Georgia. Now, with an all-out gold rush, the state was ready to move. The same time that gold was found, the Indian Removal Act passed in Congress. This only strengthened Georgia's resolve to remove the Cherokees.

The Georgia legislators got busy creating new laws. Cherokees were not allowed to conduct tribal business, enter contracts, testify in court against whites or mine for gold. In addition, the state divided the Cherokee Nation into several northern counties. At the same time, the state created laws in 1830 inciting the Indians to take their case to court. Since creating the counties, Georgia declared their ownership of Cherokee land and required everyone to follow Georgia law. Among the new laws was the ruling that whites living on Cherokee land must get a permit and then swear a loyalty oath to the governor.

Samuel Worcester, a white missionary living on Cherokee land in New Echota, refused to take the loyalty oath to the governor. He was arrested and jailed. The Cherokees fought the government, not with arrows but by going to court—eventually the Supreme Court.

Justice John Marshall declared Georgia's law invalid because the Cherokee land was not under Georgia's authority. Marshall's decision supported the Cherokee Nation and demanded the release of Samuel Worcester for living with the Indians. President Jackson said, "Chief Justice Marshall made his 'decision.' Let him enforce it."

Georgia's government ignored the Supreme Court ruling. In the Gold Lottery of 1832, Georgia began parceling out the land that once belonged to the Cherokees.[44] Land and gold lots could be purchased for ten dollars per lot. Land- and gold-hungry Georgians wanted the Native Americans gone, removed to the west of the Mississippi.

THE INDIAN HOLOCAUST

President Andrew Jackson signed the Indian Removal Act of 1830. This act gave the federal government authority to exchange land, such as that in North Georgia, for land west of the Mississippi River—an "Indian colonization zone" that the United States had acquired as part of the Louisiana Purchase. This "Indian territory" was located in present-day Oklahoma.[45]

Most Cherokees did not want to leave their homeland, but a few ruling-class Cherokees felt they should just go. The biggest proponent of this was the Ridge family: Elias Boudinot (1804–1839), Major John Ridge (1771–1839) and John Ridge (1802–1839). Boudinot wrote articles for the Cherokee newspaper encouraging the Nation to support the New Echota Treaty. The principle chief, John Ross, fought against this and asked other Cherokees to sign a petition that he would take to Washington. The government took advantage of this rift, offering money to the Cherokee Nation. The minority faction took action.

On December 29, 1835, without Chief Ross's authorization, the Ridges and a few others signed the New Echota Treaty. The treaty allowed the government to legally remove the Cherokees west of the Mississippi. It gave the Cherokee Nation two years to remove themselves and provided them with $5 million and a new homeland.[46] Only two thousand Cherokees left with the Ridges to the new territory. The remainder stayed until the bitter end.

The deadline for the Cherokee removal was May 1838. Just weeks before that deadline, John Ross gathered 15,665 signatures from almost every Cherokee remaining in the East. He took the petitions to Congress. Due to a gun duel between two representatives, Congress adjourned. It never saw the 160-foot-long petition sewn together into one long scroll. Congress never returned to Ross's petition. On the morning of May 26, 1838, federal troops and state militia began gathering the Cherokees for forced removal.[47]

John Ross tried to intercede, but all was lost. In retaliation, Boudinot and the Ridges were beaten and knifed by unknown assailants in the new Cherokee land. This is how one survivor felt about leaving the land they loved:

> Long time we travel on way to new land. People feel bad when they leave Old Nation. Women's cry and make sad wails. Children cry and many men cry . . . but they say nothing and just put heads down and keep on go towards West. Many days pass and people die very much.[48]

Michael Rutledge wrote about his grandfather Samuel Cloud's experience as a nine-year-old boy on the Trail of Tears in his paper "Forgiveness in the Age of Forgetfulness":

> *I know what it is to hate. I hate those white soldiers who took us from our home. I hate the soldiers who make us keep walking through the snow and ice toward this new home that none of us ever wanted. I hate the people who killed my father and mother.*
>
> *I hate the white people who lined the roads in their woolen clothes that kept them warm, watching us pass. None of those white people are here to say they are sorry that I am alone. None of them care about me or my people. All they ever saw was the color of our skin. All I see is the color of theirs and I hate them.*[49]

Providing a soldier's perspective, Private John G. Burnett wrote this in his diary:

> *I saw the helpless Cherokees arrested and dragged from their homes, and driven at the bayonet point into the stockades. And in the chill of a drizzling rain on an October morning I saw them loaded like cattle or sheep into six hundred and forty-five wagons and started toward the west. . . . On the morning of November the 17th we encountered a terrific sleet and snowstorm with freezing temperatures and from that day until we reached the end of the fateful journey on March the 26th 1839, the sufferings of the Cherokees were awful. The trail of the exiles was a trail of death. They had to sleep in the wagons and on the ground without fire. And I have known as many as twenty-two of them to die in one night of pneumonia due to ill treatment, cold and exposure.*
>
> <div align="right">

Private John G. Burnett
Captain Abraham McClellan's Company,
2nd Regiment, 2nd Brigade, Mounted Infantry
Cherokee Indian Removal 1838–39[50]
</div>

John Ross lost his wife on the trail, but he began again when he reached Oklahoma. He reinstated the Cherokee Nation and set up a new capital. Ross continued to fight for his people as the principal chief until his death on August 1, 1866. New Echota, Georgia, the sophisticated capital of the Cherokee Nation, was silent and lost until 1954.

NEW TOWN FOR NEW ECHOTA

New Echota, once called New Town, was lost to nature. The property was converted into farmland, and the only remaining building was the Worcester House. A group of citizens bought two hundred acres of the lost town and deeded it to the state. Archaeological excavations began uncovering foundations and roads. The Worcester House was restored. Chief Vann's Tavern was saved from the waters of Lake Lanier and moved to the site.

The Supreme Court House, Phoenix Printing Office and other buildings were dedicated on May 12, 1962. On that day the Georgia legislature repealed the laws still on the books that denied the Cherokees the right to their land.

A museum was built in 1969. A cabin was restored in 1983. A Cherokee homestead was later re-created, and in 1994 the council house was reconstructed. New Echota Historic Site in Gordon County preserves what

Vann's 1805 Tavern was reconstructed at New Echota in Gordon County in the 1950s.
Courtesy Vanishing Georgia, Georgia Archives, University System of Georgia, gor118.

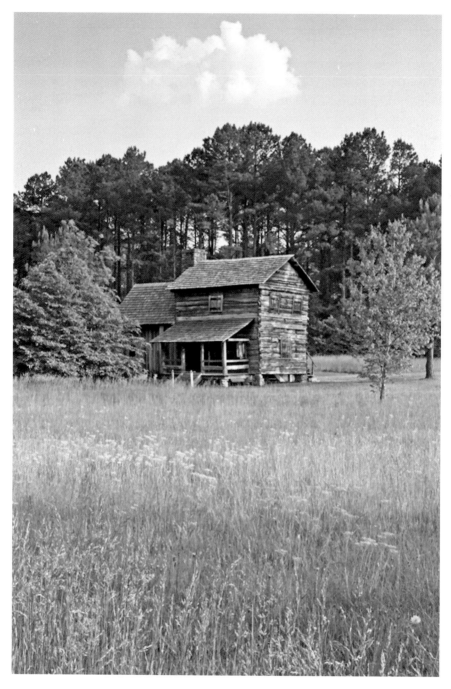

New Echota State Historic Site in Calhoun was a planned community laid out by Cherokee surveyors. *Courtesy Georgia State Parks.*

New Echota State Historic Site in Calhoun was the capital of the Cherokee Nation. This was the Cherokee Council House. *Courtesy Georgia State Parks.*

is left of the Cherokee capital.[51] Visiting this historical site, reality sets in. This was sovereign Cherokee land; the ground you are standing on was stolen. Cherokees know what their ancestors sacrificed to stay as one nation, even if they were removed from their native land. Georgians gained land and gold, but the question nags, "What did they learn?"

3.

LIVINGSTON, FLOYD COUNTY

L ife did not stop in Livingston when the government removed its status as the county seat.

Two lawyers were traveling on horseback from Cassville, the county seat of Cass County, on their way to court at Livingston, the county seat of Floyd. The lawyers, a day early for court, stopped at a small spring separating the Etowah and Oostanaula Rivers. It was a warm spring day in 1834. Sitting under a shade tree, the two men admired the surrounding hills and had this conversation:

"This would make a splendid site for a town," said Colonel Zachariah Hargrove.

"I was thinking the same," said his fellow lawyer, Colonel Daniel R. Mitchell. "There seems to be plenty of water round about and extremely fertile soil and all the timber a man could want."[52]

A stranger overheard the conversation and introduced himself as Major Philip Walker Hemphill. He apologized, "Gentlemen, you will pardon me for intruding, but I have been convinced for some time that the location of this place offers exceptional opportunities for building a city that would become the largest and most prosperous in Cherokee, Georgia. I live two miles south of here. . . I never pass this spot but I think of what could be done."[53]

Hemphill invited the lawyers to spend the night in his home. After court in Livingston, they returned to Hemphill's home to discuss plans to build a new city fourteen miles above Livingston. Colonel William Smith was called in from Cave Spring to round out the company. They talked of acquiring

the ferry rights to the rivers and laying out the land by lots. Finally, they talked about drawing up a bill for removal of the Native Americans still on the land.[54]

A fifth member of the party joined in. John H. Lumpkin was a lawyer who served as a secretary to his uncle, Governor Wilson Lumpkin. Lumpkin would deal with the legal issues, as Mitchel and Hargrove had established law practices elsewhere.[55]

The five men put their choice of town names into a hat. Colonel Mitchell remembered visiting Rome, Italy, and the beautiful seven hills. It reminded him of this place in Floyd County. He put "Rome" on a slip of paper and into the hat. That name was chosen.[56] This marked the beginning of the end of Livingston as the county seat and, eventually, as a Floyd County town.

A Little Indian Village and a Mission Station

Livingston was originally called Mission Station because the white man brought missionaries to civilize the Cherokees. Long before this, in the

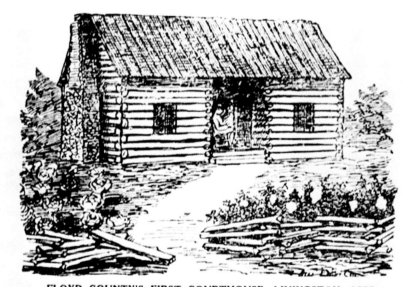

FLOYD COUNTY'S FIRST COURTHOUSE, LIVINGSTON, 1833.

Livingston was Floyd County's first seat, and this was the first courthouse. *Courtesy Vanishing Georgia, Georgia Archives, University System of Georgia, flo062.*

46

sixteenth century, Hernando de Soto may have visited the area in search of southern gold.[57] De Soto or Tristan de Luna y Arellano[58] left evidence on the McGee Bend on the Coosa River.

In 1830s Georgia, the white man had an insatiable hunger for land. The federal government had promised to deal with the "Indian problem," but Georgia was impatient. The government divided the Cherokee Nation into ten counties. The Georgia legislature decided it was time to carve up most of North Georgia, especially after gold was discovered in some of the areas. It created counties and a series of rules that restricted Native Americans on their own property.

After being surveyed by Jacob M. Scudder, a U.S. government official, Floyd County was established. The county was named after General John Floyd of Camden County, a noted Indian fighter. On December 21, 1833, Livingston was named the county seat. According to the *Rome News-Tribune*, "The county seat was placed at Livingston, now a crossroads where Foster's Mill Road and Morton Bend Road meet, but then a bustling pioneer settlement. At the time, Rome did not exist."[59]

Many cases were brought to the tiny log cabin courthouse, with Judge John Hooper presiding. Native Americans were both defendants and prosecutors in this primitive court. Hooper was often criticized for being fair with the Cherokees. Livingston was the government seat for two short years.

ONCE THE INDIANS WERE OUT OF THE WAY

What Hargrove, Mitchell, Hemphill, Smith and Lumpkin discussed in the spring of 1834 was set in motion, and the legislative act passed on December 20, 1834, moving the county seat from Livingston to the new town, Rome. This was completed in 1835. These lawyers, businessmen and well-connected politicians moved fast to grow Rome. While the Methodist church remains to this day in Livingston, the First Presbyterian of Livingston moved to Rome in 1845.[60]

Jackson Trout had built the first wooden home in Livingston. He put the structure on skids, loaded it onto a barge and pulled it to Rome on the Coosa River. Others tried to do the same, but many got stuck when they reached Horseleg Shoals.[61] At this time, Rome was virgin forest. People would just put up a tent and stay as long as they wished. The Cherokees stayed in Rome in tents, waiting for word of their removal.

The remaining Cherokees were still a problem. George Battey, in his history of Floyd County, said:

> *As early as 1837, according to a report from Capt. J.P. Sim out on, disbursing agent of the Cherokee Removal, sent from New Echota to the Commissioner of Indian Affairs, and dated Sept. 27, 1837, Col. Wm. C. Hardin was president of the Western Bank of Georgia, of Rome. Col. Hardin and Andrew Miller, agent of the Bank of Georgia, of Augusta, loaned the Government $25,000, transmitted through the Rome bank, toward the removal of the Cherokees.*[62]

Once the Cherokees were gone, Rome and Floyd County experienced remarkable growth. Livingston did not.

NOT ALL LIFE LEFT LIVINGSTON

Life did not stop in Livingston when the government removed its status as the county seat. It was a sociable and active community well into the twentieth century (1924). The hamlet had a one-room schoolhouse. The Methodist church, one of the oldest in North Georgia, coordinated activities with the school. They shared fairs and box suppers and worked so closely that no one could tell who sponsored an event. According to the locals, "There was never a lack of things to do when it was a town."[63]

Frances Erwin Evans remembers hayrides and picnics. She recalls swimming or wading in the creek and attending ice cream suppers. Mrs. Evans said that during World War I, friends would sit around the campfire and sing popular songs, such as "Over There," "It's a Long Way to Tipperary" and "A Rose Grows in No Man's Land."

As the 1920s and 1930s progressed, Rome grew and Livingston became a lonely crossroads. Looking for Livingston via Google Earth was revealing. There is no trace of the former county seat. Nothing. Residents are not even sure where the old courthouse once stood. Livingston had a very short time to serve its purpose.

If Livingston had a voice, it would be easier to understand how a short time can make a difference. In its short life, Livingston heard important court cases in its log courthouse. The school taught children about a bigger world. Churches brought salvation and messages of hope. Though

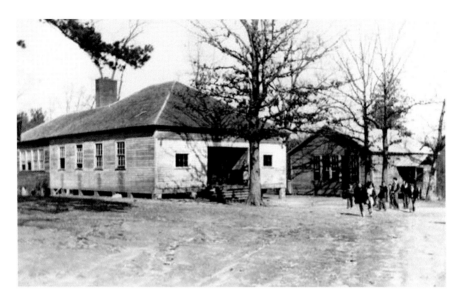

Livingston, circa 1920s and 1930s. This is the schoolhouse in the Coosa School District.
Courtesy Vanishing Georgia, Georgia Archives, University System of Georgia, flo199-86.

Livingston's voice is now silent, it speaks in the lives of those who lived there and down through the generations. Livingston's existence first spurred men to steal the county seat from them in order to build a new town. Through Rome, Livingston lives.

Part II

MINE TOWNS

4.

AURARIA, LUMPKIN COUNTY

Auraria was a phenomenon. Excitement had produced it; excitement was to end it.
—E. Merton Coulter[64]

Men were packing up and heading west. Almost twenty years after gold was discovered near Auraria, Georgia, these prospectors were infected with gold fever and now were leaving North Georgia for California. Later some moved to Colorado for new gold mines. Matthew Stephenson, a gold expert for the State of Georgia, bound up the courthouse steps and stood on the balcony to address these men. Writer Chis Worick tells it like this:

> *With his long tailed coat flapping in the breeze, he began: "Boys, why go to California?" Looking out beyond the town, he pointed his finger at Crown Mountain. "In that mountain lies more wealth than you've ever dreamed possible, there's millions in it!" He repeated himself. "There's millions in it!" The rest of his speech was never handed down, but his famous words became the rallying cry of the Georgia miners.*

Despite his plea, many of the men did not share Dr. Stephenson's vision and felt that most of Dahlonega's gold had already been found. As their overland wagon train headed west, the crack of the whip and the daily cry of "There's millions in it!" drove the Georgians onward toward the new El Dorado.[65]

This phrase became the battle cry for miners everywhere. Even American novelist Mark Twain created a character based on the miners for his novel *The Gilded Age*. Worick continues the story:

> *One day, Samuel Clemens better known as Mark Twain, was visiting one of the Georgia gold mining camps. While at the camp, Mr. Clemens struck up a conversation with James Sellers. The story of Dr. Stephenson's famous phrase used by the miners was retold to Mr. Clemens. So amused was Clemens by this popular phrase, that he created the character of Colonel Mulberry Sellers in his book "The Gilded Age." Colonel Sellers would become synonymous with "There's Millions In It!"*[66]

Over the next few decades, the phrase evolved into a colloquialism that was perpetuated in the movies: "Thar's gold in them thar hills!"[67] Who found gold in those hills? Many tales are associated with the first gold discoveries, including regarding Spanish explorers and Native Americans, but the story that sticks is the one about "Uncle Benny."

The Excitement that Produced It

Benjamin Parks was in the woods following deer tracks. In later years, he remembered the day, his birthday, October 29, 1828. "I was following a deer path . . . hoping it wouldn't turn across the [Chestatee] river, for late October is no time for fording. I wasn't walking good as common and was well nigh tired down, for I wore some new birthday boots not yet broke in."[68] With his birthday boots, Parks kicked up a rock the color of an egg yolk. He had found a gold nugget.

Parks recalled going to Preacher O'Barr to get a forty-year lease on his land and promising a 10 percent return on any gold found on his property. The preacher thought it was a joke and agreed. Parks began panning and discovered pans full of gold. Parks recalled, "It was more than my eyes could believe."[69] O'Barr found out that Parks was mining his gold and demanded to buy him out. Parks did not want to sell. Parks said the preacher yelled out, "You will suffer for this yet." Parks said he was "the maddest man in the country."[70]

O'Barr returned in a couple of weeks with three family members. Parks instructed his men not to fight, but the preacher was looking for a fight. Parks again refused to sell, and O'Barr's mother broke the sluice gate and

threw rocks at one of Parks's men. When she realized it was not working, she cried in frustration. O'Barr rushed the man, and Parks grabbed him and flung him away. Even with arrest threats, Parks would not sell.[71]

Later, Parks sold his lease to Senator John C. Calhoun of South Carolina at a fair price. According to David Williams in *The Georgia Gold Rush Twenty-Niners, Cherokees, and Gold Fever*:

> *Calhoun soon struck a rich vein and took out 24,000 pennyweights in the first month. "Then," said Uncle Benny, "I was inclined to be as mad with him as O'Barr had been with me. But that is the peculiarity of gold mining. You will go day after day, exhausting your means and your strength until you give it up. Then the first man who touches the spot finds the gold the first opening he makes.[72]*

Five others claimed to be the first. But no physical record of the gold discoveries exists except one for August 1, 1829, when the following notice appeared in the *Georgia Journal*:

> *GOLD. —A gentleman of the first respectability in Habersham county, writes us thus under date of 22d July: "Two gold mines have just been discovered in this county, and preparations are making to bring these hidden treasures of the earth to use."[73]*

No matter who is really responsible for the first gold dug out of the North Georgia mountains, according to the Georgia Historical Society, "The result was the same: thousands of miners swarmed into the mountains in what the Cherokees called the 'Great Intrusion,' and the Georgia Gold Rush was on."[74]

This excitement did not extend to the Native Americans who had lived in North Georgia first. Most of North Georgia was Cherokee land, a sovereign nation that did not have to abide by the laws of the state of Georgia. President Andrew Jackson was tough on Indians and wanted them moved to a different territory, preserving Georgia's rich minerals and gold for Georgians. So, when laws were passed ignoring previous treaties, Jackson supported the state. Gold-hungry Georgians did not want to be squatters, but owners of this land. So, Jackson's inauguration on March 4, 1829, along with the discovery of gold on Cherokee land later that year, marked the beginning of the end for the Cherokee Nation in Georgia.[75]

AURARIA

Thousands poured into the area looking for gold with few impurities. The first group of intruders settled on a ridge between the Chestatee and Etowah Rivers.[76] This was the perfect spot for gold mining because placer mining required water to wash out the sand and gravel, usually in water streams. Spades, pans and rocker cradles lined the streams. The settlers formed a community around the cabin of an early squatter named William Dean. Nathaniel Nuckolls, another early invader on Cherokee land, set up a small tavern. Miners needed their beer, and a town was born around the tavern.[77]

Initially known as Deans and then Nuckollsville, the town struggled to find a name. Nuckollsville perpetuated a story that in this rough area, bare-knuckled fights broke out often. This area was, in fact, tame. Nightly brawls were not reported. Some mischief was reported, but only one murder in this town was ever recorded. Soon the town drew people of all classes, races and descriptions, with one focus: gold.[78] The town was finally named Auraria after several attempts to use the word root "aura," meaning gold. Major John Powell, a prominent citizen, selected the name that everyone liked. Auraria meant "gold mine"—the name reflects the only reason for the town.[79]

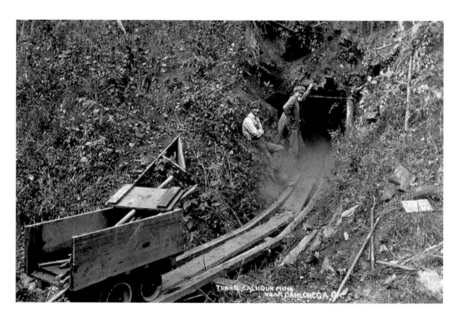

Gold was discovered in Auraria, Georgia, in 1839, ten years before the California Gold Rush. This is a gold mine outside Dahlonega. *Courtesy Georgia State Parks.*

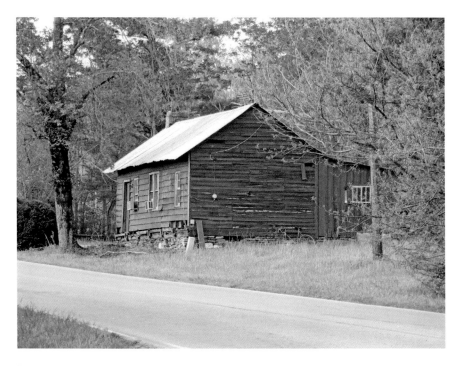

First called Nuckollsville, the town was later renamed Auraria. The name meant "gold mine" or "gold region"—the reason for its existence. This is one of the old homes. *Photography by Douglas Boyle.*

THE CHARACTERS IN TOWN

The gold brought many miners to Auraria in 1829. They were a motley crew coming from across the nation and even Europe. Some miners came involuntarily as slaves, such as those owned by John C. Calhoun. There were free African American miners and some Cherokees as well. Some miners were farmers who came to supplement their meager incomes, but most of them were just men looking to get rich quick. They stayed and helped the town grow until 1840, when the easy mining had extracted most of the gold. Then there were more than two hundred people in town. Coulter writes that Auraria had a mixture of businesses and people comprising "diggers, lawyers, shopkeepers, peddlers, thieves and gamblers."[80] The town also had doctors, bartenders, hotel operators and "Grandma Paschal, the Angel of Auraria."[81]

No liquors were allowed at Grandma Paschal's place. When she moved to Auraria in its first year of existence, she set up shop to provide a wonderful place to stay but offered not a thing to drink. She set up the Antioch Baptist

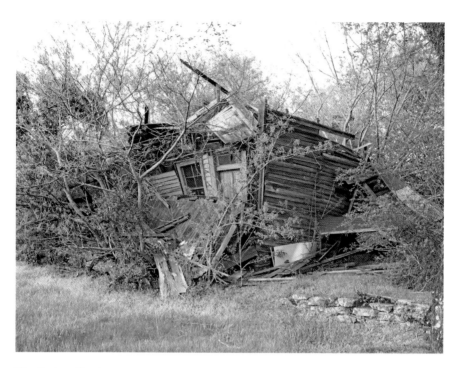

The Graham Hotel was built in 1826 to serve the early Georgia gold miners. Once registered as a historic building, the Graham is now a pile of lumber. *Photography by Douglas Boyle.*

Church in a hastily built log cabin. When the structure fell down, she held services in her tavern dining room. She was also the unofficial town nurse when the doctor was not available. Grandma Paschal stayed in Auraria to the end; she never deserted her beloved town.

THE EXCITEMENT THAT ENDED IT

Almost as quickly as it grew, Auraria became a ghost town. Several factors contributed to its demise, most significantly the county seat, the U.S. Mint and the next gold rush.

Lumpkin County needed a county seat. Once the Land Lottery of 1833 was completed, judges would select a county seat. They made a trip to Lumpkin County and voted on three locations for the county seat. According to Coulter:

They made their selection, only after a good deal of disagreement and wrangling. Three lots were voted on, none of which was 6.64, on which Auraria stood, but one of them was only about a mile to the northward. Two of the judges immediately favored Lot 950 and another finally agreed, but the fourth one disagreed and the fifth judge was absent. This lot was about five and a half miles northeast of Auraria and about a half mile from the diggings on Cane Creek. [82]

The county seat would bear a new name, Dahlonega. Aurarians were not happy about this decision. The logical choice should have been Auraria. With the government's choice, many Auraria businesses left to resettle in the county seat, including the town's newspaper. Coulter reports:

Lawyers and doctors and butchers and bakers and candlestick makers (if there had been any) and even the county government might move away from Auraria without badly crippling the town; but when, also, the town's newspaper, its vehicle of information and its propagation to the outside world and of news from the outside world in when this vehicle rolled away, the beginning of the end was in sight. But when gold itself, the life and essence and very origin of Auraria, began to play out, and no more people came and those here began to move away, then there was absolutely no hope. [83]

This was not the only governmental action that killed Auraria. The decision was made to build a U.S. Mint in the South. Dahlonega was selected as the site. In November 1833, in Grandma Paschal's hotel dining room, plans were drawn up for the mint.

The Dahlonega Mint opened in 1838 after many construction problems due to the remote location. The mint never had enough qualified people to manage it. Despite the obstacles, the mint produced over $6 million in gold coins over the twenty-plus years of operation. The Confederate government shut down the U.S. Mint in 1861, and it never opened again. Later, the property was given to North Georgia College. Auraria's greatest loss was when gold was discovered in 1849 in California and later in Colorado.

There was a resurgence of mining near Auraria because of newer mining technologies. Despite this renewal, the Georgia gold industry stalled with the Civil War and the closing of the Dahlonega branch of the U.S. Mint. According to Johnson, "After the war, as the region began a slow recovery, there were several sporadic new mining efforts, but these limped along until the large scale revival attempt at the end of the nineteenth century." [84]

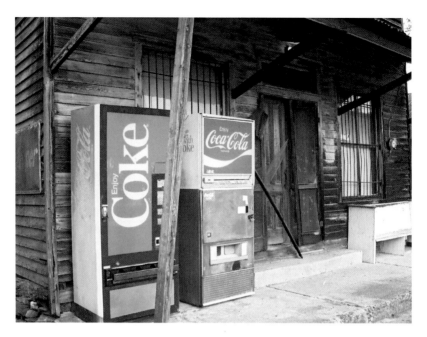

Auraria, Georgia. Woody's Grocery Store still advertises this popular product. *Photography by Douglas Boyle.*

Few homes remain in Auraria, Georgia. This is an Auraria home. *Photography by Douglas Boyle.*

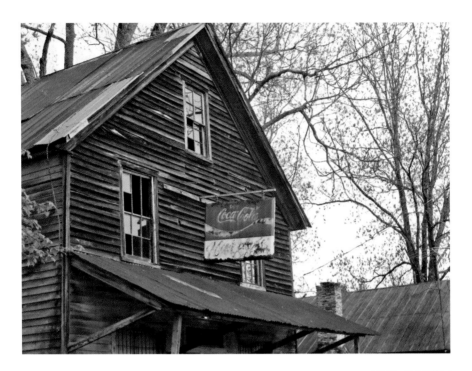

Above: Woody's Grocery Store stands in the center of what was once the first gold rush of America. Now it is a North Georgia ghost town. *Photography by Douglas Boyle.*

Right: This old general store served as a tavern for miners in the early 1800s during the Georgia Gold Rush. *Photography by Douglas Boyle.*

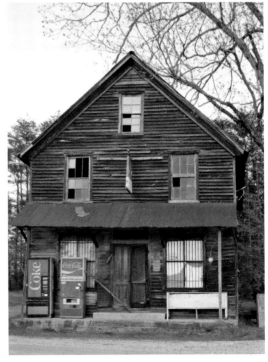

In 1848 Auraria had over four thousand residents. A few days after the California Gold Rush was announced, the population dwindled to less than three hundred.[85] George W. Paschal visited his mother in Auraria in 1858 and noted that the town had "fallen greatly into decay."[86]

Dahlonega fared much better. After sucking the lifeblood from Auraria, Dahlonega went on to glory. It is a popular mountain tourist town and markets itself as the place where the Georgia Gold Rush began. Little credit is given to the place called Auraria. Today, it is practically nonexistent. All that remain are a historical marker and decrepit buildings.

Auraria is lost, but something bigger came from it. In February 1858, the Russell boys of Auraria—William Green, Levi and Oliver—left for the foothills of the Rockies in search of more gold. They found it on the sandy banks of Cherry Creek, and the rush was on. The boys named the area "Auraria." In 1860, a town across Cherry Creek merged with Auraria. The new town was called Denver.

5.

ESTELLE, WALKER COUNTY

To know nothing of what happened before you were born, is to forever remain a child.
 —*Cicero*

Estelle is lost. Of all the towns in this book, Estelle is the hardest to find. Located 170 miles northwest of Atlanta and 25 miles southwest of Chattanooga, Tennessee, what remains of Estelle is between Rock Spring and Lafayette in Walker County, Georgia. Even finding the Estelle Mines Trail is difficult. Note these directions given by Georgia Trail Reviews:

> *From Highway 27 in Lafayette take 193 west over Pigeon Mountain and right after the sharp curve at the bottom, there is a pull off on your left where the fire-road leading to the trail begins. When the trail ends into a gravel parking lot take the road to your right and it will lead you to Hog Jawl Road and that will lead you back to 193, where you will take a right and head back east to your car.*[87]

If finding a hiking trail is this difficult, finding what remains of Estelle is even more challenging. Most of the remnants are a difficult hike, covered with thick Georgia undergrowth.

FINDING THE REMAINS

Locating the Estelle Cemetery will centralize the search. The cemetery has about 250 graves for soldiers from the Civil War, World War I and World War II. Thanks to the efforts of volunteer groups such as the Confederate Grave Preservation Group and State of Dade SCV Camp 707, the Estelle Cemetery is maintained.

The cemetery is two hundred to three hundred yards north of the old mine entrance. Looking south of the cemetery, portions of the old Tennessee, Alabama & Georgia Railroad (TAG Route) are visible. This TAG railroad brought supplies to Estelle Mining Company and the mining town. The train took the iron ore from Estelle mines to Chattanooga for processing.[88]

Photographer and explorer Christopher Muller photographed and measured seven remaining mine tunnels. He documented his discoveries as follows:

Tunnels are numbered from east to west and pictured below from west to east. Distances are measured by grade from Estelle. Tunnel lengths are estimated to the nearest 50-foot increment.

Estelle Mining Company Railroad Tunnel No. 7, looking toward the west portal. Only seven tunnels remain to mark the town of Estelle, Georgia. *Photograph by Christopher Mullen, SteamPhotos.com.*

Estelle Mining Company Railroad Tunnel No. 6, east opening of about eighty feet of remaining section. Special rails were made to fit the mines. *Photograph by Christopher Mullen, SteamPhotos.com.*

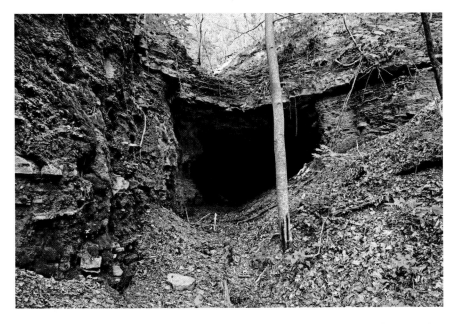

Estelle Mining Company Railroad Tunnel No. 1, west portal. At one time Estelle had over two hundred people living and working in these mines. *Photograph by Christopher Mullen, SteamPhotos.com.*

Tunnel 1 (0.7mi from Estelle): 600 feet long (longest and highest)
Tunnel 2 (2.5mi from Estelle): 250 feet long
Tunnel 3 (2.6mi from Estelle): 200 feet long (shortest)
Tunnel 4 (2.7mi from Estelle): 350 feet long
Tunnel 5 (2.8mi from Estelle): 500 feet long (west end collapsed, approx. 450 feet intact)
Tunnel 6 (3.0mi from Estelle): 400 feet long (both ends plus center collapsed— two remaining sections are approx. 80 feet and 40 feet)
Tunnel 7 (3.2mi from Estelle): 400 feet long (east portal fully blocked by slide)[89]

THE TOWN AND THE PEOPLE

A walk in the woods near Pigeon Mountain in McLemore Cove would bring questions to your mind as you stumbled upon an abandoned train tunnel and seven smaller tunnels leading nowhere. What happened here? Nature hides what remains of what was once the prosperous mining town of Estelle in the hills of Northwest Georgia.

Abundant soft iron ore was embedded in the sides of these lush Walker County Mountains. In the book *Walker County Georgia Heritage, 1833–1983*, we learn that in the early 1900s Estelle was mining vast quantities of high-grade iron ore. The book also states, "These mines were dug into the same foothills of Pigeon Mountain where just a few years earlier Gen. Braxton Bragg stood waiting for an unsuspecting union army to walk into his trap."[90] This area is still hiding things from the unsuspecting hiker.

At one time these woods were home to between 175 and 230 miners and their families. The town used to be called Shaw, but when the Estelle Mining Company incorporated on June 24, 1897, it was then known as Estelle, Georgia. The company owned forty-six hundred acres and had instant access to a railroad to resupply the town commissary and for the shipment of ore. The commissary had everything the miners and their families needed: furniture, clothing, household items and groceries. The town prospered.

The town had a mule stable to accommodate the thirty mules used in the mine. A blacksmith and machine shop were both run by the master mechanic, who took care of the maintenance of all the equipment except the cars—they were built and repaired in the carpenter shop. The town also had someone designated to repair the miners' homes. A barber would cut

hair for a reasonable price. A boardinghouse was home to miners without a house.[91]

A mining magazine in the early 1900s wrote an extensive article about Estelle, describing the town as having a group of buildings: "wash and locker houses, a galvanized iron building housing the steam plant, a saw mill, which cuts timber taken from the property, for use in the building cars and shoring the mines."[92]

Estelle was not a backwoods town. Though located in the Cumberland range of mountains, this town educated its children. Two schools, funded by the county, accommodated 150 white children. The little red schoolhouse was in Depot Hollow and offered a full curriculum. The other school, the Estelle School, had three rooms and may have been for the forty "colored" children. This schoolhouse was located near the present cemetery on a hill.[93]

Healthcare was provided, because the men of Estelle paid for 70 percent of the cost to retain a doctor. The town had two doctors. Dr. Jim P. Woods and Doc Gates cared for the injured and delivered babies. Mining ore was dangerous. One young boy was run over by a dinky car and died the following day.[94]

Caring for Estelle's souls was Reverend John Bill Devlin, the pastor of the only church in town, the Church of God. Miners did not work on Sundays. Archival data reports that Reverend Devlin was loved and respected by the community; they enjoyed his sermons.[95]

Sunday was the day off from work and the day for recreation after church. The miners played horseshoes, went fishing and went swimming in the falls in "The Pocket." The Pocket remains a favorite place to spend a restful Sunday afternoon.

THE WORK

Mining would have been impossible in this rugged terrain without the use of rail. Christopher Muller describes the two rail systems used:

> *Estelle Mining Company built a private narrow gauge railroad westward from the Chattanooga Southern Railroad (later Tennessee Alabama & Georgia, or TAG Railway) at Estelle. The 6-1/2-mile railroad served a number of mines along the west side of Pigeon Mountain between Estelle and its terminus at High Point. The railroad required*

seven tunnels, all straight and unlined with lengths ranging from 200 to 700 feet.

Gravity-powered cars first carried ore out of the mines. The ore was then transferred to ten- and twenty-ton cars and hauled east on the narrow-gauge railroad to Estelle. At Estelle, soft ore was loaded directly into standard-gauge rail cars, whereas the hard and semi-hard ore was first run through a crusher before loading. Steam trains then hauled the loaded cars north to the Southern Steel Company's furnace at Chattanooga.[96]

TAG depended on the Estelle Mines for a large portion of its freight business. And the mines supplied most of the ore for the Chattanooga Iron & Coal Corporation's furnace.[97]

A woman named Nellie Wallin managed the scales, weighing the ore cars when they went to the crusher. The ore left the crusher and then went to a chute and onto the rail cars.

When the mine needed workers, boys as young as seven were enlisted to load ore. Ten-year-old boys worked at the crushers, and twelve-year-old boys became "mule boys." Early records explained, "The mule boys would leave home around six-o'-clock in order to get the mules prepared for entry into the mines at six-thirty. The mule boys worked ten hours a day for twenty cents per hour."[98] Other jobs available to men and boys included firemen, engineers, push boys and breakies.

THE END

Things slowed in 1919 because of labor strikes. Major strikes included an iron- and steelworkers' strike in September 1919, a bituminous coal miners' strike in November 1919 and a major railroad strike in 1920. These strikes damaged the iron-ore market. According to economist J.R. Vernon, however, "By the spring of 1920, with unemployment rates rising, labor ceased its aggressive stance and labor peace returned."[99] Estelle mining was sold to Iron Products Corporation in 1919, but the mine closed in 1924.[100]

Part III

DROWNED TOWNS

6.

BURTON, RABUN COUNTY

I want to buy you out.

—*J.E. Harvey*

I t just ruined their lives. They never were satisfied." Willie Elliott remembered when Georgia Power bought all the property in her hometown of Burton. "I don't think they got anything [like] it was worth for what it did to the community." Ms. Elliott was remembering the days at the end of 1919 when the dam closed and flooded her town. She was interviewed for *Foxfire 10*. "All I remember [about the flooding after the dam was constructed] is that they didn't tear down the house, it was left standing. We took all the belongings, of course. I remember my father making the remark that they moved out the last load of furniture just before it got high enough to flood what he had in the wagon."[101]

BEFORE THE FLOOD

Before December 22, 1919, Burton was the second-largest town in Rabun County, with two hundred citizens.[102] Rabun County, Georgia, was created one hundred years and a day earlier from Cherokee lands by the Georgia legislature on December 21, 1819, and named for William Rabun, the recently deceased governor of Georgia.[103] Rabun County is

the northeasternmost county in North Georgia. Beautiful tree-carpeted mountains surround the idyllic location. In the early 1800s, early settlers found gold where Dick's Creek and the Tallulah River join; this was the reason for the town's founding.[104]

The bottomlands in Burton were some of the best for growing corn, soybeans, some tobacco, garden vegetables, fruits and walnuts. Mary George Poss remembers the mules turning the syrup mill and the animals. "There were sheep, cows, hogs, chickens, and wild game for their meats."[105]

The town was prosperous, with residents living in large homes on both sides of the Tallulah River. The community had three general stores, a sawmill, a church/school building and a post office. Three general stores had difficulty keeping their shelves full. According to the Rabun County Historical Society, "Any supplies had to be brought in with a day's wagon ride to Clayton or Tiger."[106]

The Burton School was a one-room school that also served as a church. In 1914, there were seventy-eight children enrolled. According to some accounts, Rabun County spent about five dollars per year per student. There were blackboards but no textbooks.[107]

Music was a priority in Burton. Dr. John C. Blalock talks about his early life in the town, including singing conventions and music school. Blalock says, "A singing convention lasts all day!" He remembers singing school, held every year for two weeks. He said, "The teacher would call on you to see if you could sing, and he found right quick I couldn't even carry a note to the post office."[108] Blalock said the church bought an organ, but only one girl could play it. It was the only instrument in town. Members of other communities would come and borrow the organ for their services.[109]

SELLING BURTON

"Mr. Blalock, I want to buy you out." J.E. Harvey was the local entrepreneur who bought most of the land for the Georgia Power Company in Rabun County.[110] In a 1982 interview, published in *Firefox 10*, Dr. John C. Blalock explains what happened:

> *I'll give you the exact way it was bought, every bit of it. The power company first sent up three surveyors, all graduates of Tech, and surveyed all of this. The surveyors stayed at our* [boarding] *house two or three*

months, all the time they were doing it. . . . They said they were surveying for the government. That's all they ever told anybody.[111]

Blalock continued to explain how "old man Harvey" went to Clayton and found out how much property tax everyone paid in Burton. He told Blalock's father that he was working for the government and that he wanted to buy the property for some sort of utility. Harvey told Blalock that he could live there the rest of the year, but they wanted them out by the next year.

Harvey and Blalock negotiated for his property on both sides of the river and his store. Blalock would not sell the materials in the store. He could have gotten $25,000, but he got $9,000 instead. Harvey went to every house and made everyone an offer. Blalock remembered, "And he got nearly all of them." Most were satisfied, but some found out they were swindled and demanded more money—and got it.[112] In all, sixty-five families sold property to create Lake Burton.[113] Another Burton resident shared:

Dad had a little farm down there. I don't remember how much land my family had then; the lake covered it up. That's what they done, you know. Water came to about eight feet over where we lived. . . . [My dad] took the money and went to Chechero and bought another homestead. All the rest of the people in the community done the same—one here and one yonder, to and fro. They just took up their beds and walked.[114]

After the flood, one resident said, "The water rose so fast, the steeple of the church was seen floating in the lake for years."[115] Graveyards were dug

Georgia Power built a dam to create Lake Burton in 1920. Some of the buildings were moved from Burton; others washed away. *Courtesy Rabun County Historical Society.*

up, and bodies had to be moved to a new location. Some protested and left the graves in place.[116]

The water started filling Burton on December 22, 1919. The lake was completely filled by August 1920 and has stayed at full pool ever since.

Burton's Sacrifice

Lake Burton at one time was the largest producer of power for Georgia. Now, the lake provides power only during peak periods for Atlanta. Lake Burton is a 2,775-acre reservoir owned and operated by Georgia Power. Lake Burton is 1,855.5 feet above sea level, making it the highest and first in a chain of six power producers in Rabun County. The others are Lake Seed, Lake Rabun, Tallulah Falls Lake, Lake Tugalo and Lake Yonah.[117] Beyond energy production, Lake Burton creates new life in fish, fauna and flora.

If the residents of old Burton could see the purposeful beauty of Lake Burton, they would be proud of their sacrifice. Lake Burton has not only energized North Georgia but also revitalized the natural environment.

According to the Lake Burton Civic Association, the area is known as the "vegetation cradle" of eastern North America, with more than 4,200 plant species. The magnificent beauty of the mountains is dotted with wildflowers, herbs, vines and trees.

The Georgia Game and Fish Commission reports that the mallard duck is the most prevalent duck that winters in North Georgia. Other transient birds include Canada geese, wood ducks, loons, canvas-backs, sandhill cranes and great blue herons.

Campers in the area might like to know that bobcats and a large population of black bears live in the forest. Lake Burton forests accommodate the red and gray fox, white-tailed deer, raccoon, opossum, gray and flying squirrel, ruffed grouse and wild turkey. The fortunate visitor to the area may get a glimpse of the bald or golden eagle.

The streams feeding Lake Burton are stocked with spotted and largemouth bass, bluegill, crappie and yellow perch. The Lake Burton Civic Association reports, "Several spotted bass greater than four pounds have been found in DNR samples."[118] Lake Burton holds state records for walleye (eleven pounds) and yellow perch (two and a half pounds). White bass also approach record-breaking size.[119]

Burton residents unknowingly sold their homes, businesses and land at a sacrificial price. Lake Burton Dam closed its floodgates on December 22,

1919, and the lake began to fill. Some who remembered those days felt that the people were not really satisfied with the situation. They felt lost, but what could they do?

As Burton drowned in eight months, the people relocated to higher ground. They would never know what the next one hundred years would do to their magnificent land. The waters would bring power to the growing metropolitan area of Atlanta. Thousands of people have enjoyed Lake Burton, and its sixty-two miles of shoreline provide many opportunities for camping, fishing, picnicking, boating and hiking. New plants, animals and fish thrive in and around the peaceful, cool blue waters. Burton is dead and buried, but with Lake Burton, this portion of North Georgia is born again.

7.

ETOWAH, BARTOW COUNTY

*The wild beauty of the hills and the valleys and the rushing Etowah River
captivated him.*
—*Mark Cooper Pope, speaking of Mark Anthony Cooper*

Miss Lillian Ray Bohannon Butler, ninety years old, remembered her childhood. She was eight years old in the mid-1930s, living next to one of the old furnaces built by Moses Stroup and the only remaining structure from Cooper's Iron Works; the rest of the Etowah iron furnaces were destroyed during the Civil War. The family had a milk cow that roamed about the ruins of Etowah all day and came home at night. The animal was penned inside the middle of the surviving furnace. If the cow did not come home, Lillian's mother would make her go out and find the cow late in the afternoon. Little Lillian had to walk up the road to the old Etowah and look in the ghost town for the cow. The little girl would go alone into this spooky place as the sun was going down.

Ms. Lillian remembered, "And wouldn't you know it, almost every time I would find that cow grazing in the tall green grass in the old cemetery. I always hated to go up there. It frightened me so! I was just a little girl."[120]

Etowah now resides at the bottom of Allatoona Lake in Bartow County, Georgia. All that remains is that one iron furnace, part of a day use area that was once the centerpiece of a thriving industrial town.

An Iron Ore Furnace

Standing tall as the only remains of the Etowah mill village is a large trapezoid built of local rock. Cooper's Iron Furnace remains as a monument to the once industrial area before the Civil War. The facility was a cold-blast furnace using iron ore, limestone and charcoal. These materials were brought across on a trestle to a hole at the top of the furnace. Coal was poured in and ignited, and then a layer of iron ore was added, followed by limestone, charcoal and so forth.

Bellows were used to raise the heat on the ore and limestone until they merged together. The melted limestone pulled impurities from the iron, then the impurities were scooped out and the molten iron slid to the bottom of the furnace. The workers unplugged an opening at the bottom of the furnace, and the molten iron flowed. According to a poster at the Cooper's Furnace Day Use Area, "The liquid iron flowed from the furnace

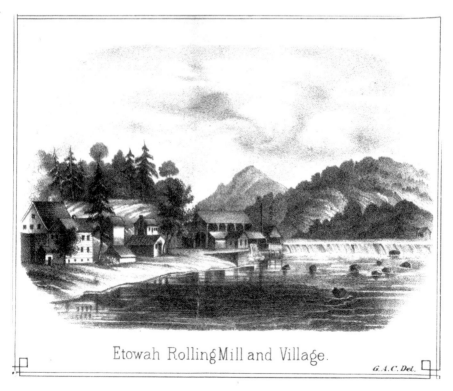

Etowah Rolling Mill and Village.

G.A.C. Del.

Mark A. Cooper created Etowah as an industrial complex. By the 1840s the village contained a blast furnace, a foundry, a flour mill, two corn mills, a sawmill, shops and warehouses. *Courtesy Bartow History Museum.*

to the casting shed and into a trench with lateral spurs which resemble a mother pig feeding her young. Hence, the finished product was known as 'pig iron.'"[121]

A water-powered pump provided air to heat the materials. A wooden water flume was fueled by the Etowah River and extended one-quarter mile upstream.

Cooper's furnace worked forty-five weeks a year and produced up to thirty tons of pig iron each week. The price of iron at the time was brought up to $25 per ton. In modern terms, Etowah Mining Company would have grossed about $21,000 per week.[122] Once one of the busiest places in the entire South, Etowah grew into an industrial town with hundreds of workers and included slave labor.

Originally constructed in the late 1830s by Moses Stroup and his father, the iron furnaces were the early industrial parks of Bartow (then Cass) County. In 1847 Georgia congressman Mark Anthony Cooper and a financial partner, Andrew M. Wiley, purchased the furnace and many related businesses from Moses and worked together to build Etowah.

The manufacturing town grew to two thousand people at its peak and contained a rolling mill, flour mill, carpenter shop, foundry, spike and nail mills, a hotel and workers' homes. Etowah had a spur track connecting to Western Atlantic Railroad (W&A) that Cooper financed himself. The railroad had an engine called Yonah. It not only shipped freight to Etowah Crossing—Yonah played a role in the Great Locomotive Chase during the Civil War.

The products made and shipped from Etowah were pots, tools, cannons, spikes, nails, pig iron and other molded or rolled iron. The rails for Cooper's beloved railroad were first manufactured in Etowah. Many people worked to build this antebellum town, but it began with the passion of one man for the land.

It Is All about a Man

Mark Anthony Cooper III has nothing to do with the reason Etowah is underwater today, but he has everything to do with the town's beginnings and purpose for existing. Bartow County (formerly known as Cass) was one of the richest mineral regions in the country. State congressman Mark A. Cooper discovered this truth firsthand while traveling through Cass County

on his gubernatorial campaign. He stopped at an iron furnace located near Stamp Creek. This visit created a booming pre–Civil War industry town in North Georgia.

Moses Stroup introduced Cooper to his future. After talking about the iron ore business, he spent the night under the North Georgia stars and decided this was his future.

Etowah was built to be an industrial town. Cooper gave it purpose; he wanted to make products for shipment throughout the South. And for such a time as this, in Etowah, Cooper manufactured products, prodded the railroad's growth and supplied the Confederacy with arms and ammunition.

The first female U.S. senator and Bartow County legend Rebecca Latimer Felton remembered visiting Etowah and Cooper as a young girl:

> I was ten years old in the summer of 1845. We heard a great deal about the iron works at Cooper and Stroup in Cass County. My parents decided to take an outing in that direction so we might see where iron ore was turned into cooking vessels and rolling into long flat bars.[123]

Rebecca continued her description of Cooper's Iron Works:

> The works were in full blast, he [Cooper] said, and after supper was over we would see the big open furnace where the iron was made liquid, and strong men would rush up with long handled ladles, dip out the molten ore and put into the dozens of molds for pots, ovens, lids, skillets, and fry pans, etc.—that were already set in proper places on a level space, covered with sand to be poured into.[124]

Senator Felton recalled her first impressions of Mark Anthony Cooper: "I thus saw Major Cooper in the prime of his splendid manhood. He was a typical Southern Gentleman."[125]

ETOWAH LIFE AND COMMUNITY

Since there are few pictures of Etowah, we rely on records of past residents. The town is described by J.W. Joseph as having a boardinghouse and twelve dwelling houses. There were two hundred acres of farmland and four acres of vineyards. There were private log homes. The private residence for the

owners, Stroup and Cooper, were located up the river at a distance from the mills, to get away from the noise of machinery.[126]

In 1852, Etowah had a population of 1,832. This may not seem very large, but the county seat, Cassville, was the largest settlement, with a population in this same year of 1,794.[127]

Francis Adair interviewed Mrs. Roe Knight in 1930 and left this tour of the town:

> *The land was then laid off into streets, lots, and localities. A few of the more important structures which immediately went up were: the Church, school house, President's office, bank, boarding house, and several large stores. The chief boasts of the town, however, were the railroad turn table and the post office.*[128]

Mrs. Knight mentioned a barrel factory with a usual daily output of 250 to 300 barrels. She spoke of a brewery and mentioned an iron warehouse connected to the railroad line, constructed to store all the pig iron produced when it was not profitable to sell it.

In later years, after the war, ruins of the bank vault dug into the cliffs along the river, and remnants of the old hotel overlooked the river and the mouth of Allatoona Creek.[129]

Jodie Hill remembers Etowah from his childhood:

> *It was quite a village with a bank, 3 churches, and a school, and a cemetery—a big cemetery. I am sure most of the cemetery is still above the water on a little island.*[130]

CIVIL WAR

Cooper tried to get Confederate politicians to use his ironworks for the war effort, but his offer was ignored. Instead, Cooper became an arms dealer for most of the war and finally just gave the ironworks away to a company that would manage the company for the Confederates. The ironworks became a war target that was used and finally destroyed by the Union.

According to Cooper's great-grandson, "Mark A. Cooper was crossing the river when the troops destroyed the rolling mill, the flour mills, and the other facilities and buildings."[131] Etowah Mining Company and Cooper's Iron Works were no more. It was May 1864, and Cooper had lost his two

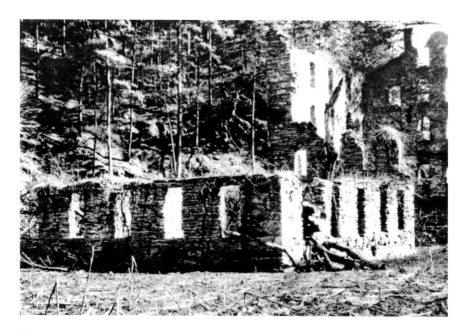

The remains of the Etowah Flouring Mill. Written on this photograph: "War is hell. Mark Cooper Iron Works near Cartersville, Ga., destroyed during Civil War." *Courtesy the Atlanta History Center.*

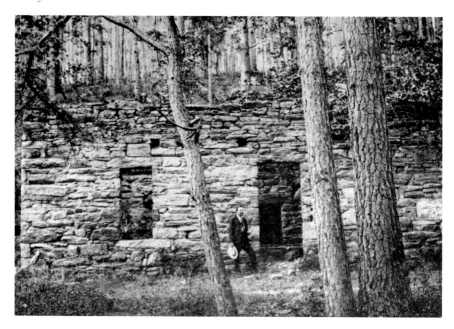

The ruins of the Etowah Bank. Etowah at one time had twelve hundred residents, but it was destroyed during Sherman's March. Now it lies beneath Allatoona Lake. *Courtesy Bartow History Museum.*

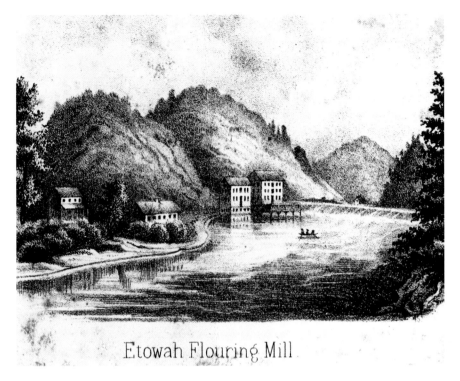

Etowah Flouring Mill

The Etowah Flouring Mill stood near where Allatoona Dam is today. The remnants of the flour mill were destroyed during the dam construction. *Courtesy Bartow History Museum.*

sons to the cause and his company to the Confederates and now the Union. Glen Holly, Cooper's home on a little knoll near the Etowah River, remained unscathed. Cooper would live out his life there and then was buried on the land. The graveyard remained until 1949, when the town was drowned after construction of Allatoona Dam.[132]

AFTER THE CIVIL WAR

Corra Harris, a Bartow County author, wrote an article on March 1, 1934, that discussed a monument Cooper placed in Etowah to honor the friends who helped him through the depression of 1857. The tall statue was built by a debtor to honor his creditors. Harris shares this story about Cooper's Friendship Monument:

The Federal Army destroyed his Iron Foundry and flung the monument into a well. Mrs. Lilly Bentley . . . found the monument standing up in the well sixty-five years later. As a result of her discovery the citizens of Cartersville came and pulled it out and set it up in the downtown park, where it may be plainly seen from the windows by every passing train.[133]

DAM!

The next phase in Etowah's life was the dam. The U.S. Army Corps of Engineers began working on the Allatoona Dam project in 1941, but due to the world war, the project was stalled. In 1946, the work continued. By 1949, the dam was complete and the waters began pouring into Etowah. There was still a town after the Civil War, but not much of one. The waters covered the remnants, including Glen Holly, Cooper's home. Though many years too late, the waters may have served as a baptism or a cleansing from the ashes of war.

The town was not salvaged, but Etowah had an extensive graveyard. Some of the graves in the town cemetery were moved and some remained. The cemetery was so large that portions stick up on Goat Island in the middle of the lake. On a copper plate, green with age on a marble foot in Oakhill Cemetery in Cartersville, these simple words explain what happened at Glen Holly in the Etowah village:

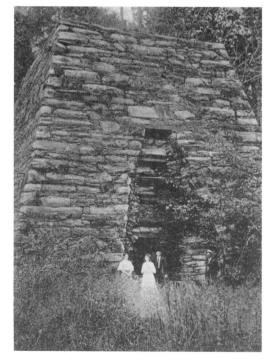

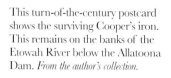
This turn-of-the-century postcard shows the surviving Cooper's iron. This remains on the banks of the Etowah River below the Allatoona Dam. *From the author's collection.*

Sophronia and Mark A. Cooper were reinterred in their iron caskets in
Oak Hill Cemetery when their family graves were moved from Etowah as
Allatoona Lake filled in 1949. *Courtesy the Atlanta History Center.*

In Memoriam
This family cemetery containing eleven graves was removed from Glen
Holly in 1949 to permit construction of Allatoona Dam and Reservoir.
Erected by Corps of Engineers, U.S. Army

Sophronia and Mark A. Cooper were reinterred in their iron caskets in
Oak Hill Cemetery when their family graves were moved from Etowah as
Allatoona Lake was filled in 1949.

These words appear on a board on a hiking trail at the Cooper's Furnace
Day Use Area: "Since the ironworks at Etowah were too valuable to the

The Etowah Covered Bridge survived the Civil War, but not the waters of Allatoona Lake. *Courtesy the Atlanta History Center.*

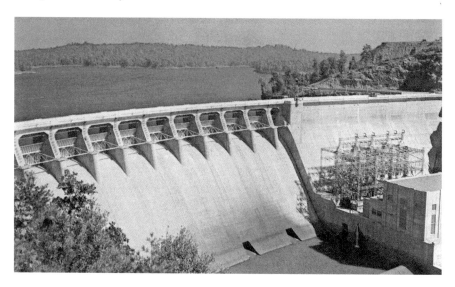

The U.S. Army Corps of Engineers completed Allatoona Dam in 1949, creating Allatoona Lake and drowning Etowah and Allatoona. *From the author's collection.*

Confederacy to be left intact, Federal troops set them ablaze along with much of the surrounding town. It was a fatal blow. Industrialist Mark Cooper lived on at his home 'Glen Holly' until 1885, but Etowah would soon be shrouded in the mists of time and forgotten by most."

Standing near the enormous iron furnace that once blazed hot and poured molten iron offers a unique perspective on history. This furnace supplied the iron to build railroads and the nails to make homes. Iron skillets and pans were poured here to provide for a family. The everyday things we take for granted were harder to come by in the mid-nineteenth century. Cooper had a vision for his beloved town, state and country.. He lived a long life in the town he created. Even though Sherman decimated this industrial town, Mark Anthony Cooper's iron-clad impression has marked North Georgia's history.

8.

ALLATOONA, BARTOW COUNTY

It is a second Chattanooga; its front and rear are susceptible of easy defense and its flanks are strong.
—General William Tecumseh Sherman in a message to
John E. Smith on Allatoona

The railroad had a significant impact on Bartow County and Allatoona. During the construction of the Western and Atlantic (W&A) Railroad from Atlanta to Chattanooga, a few obstacles made the construction difficult. Michael Garland has researched the railroads:

> *In order for trains to get through the Allatoona Mountains, a deep cut or pass was created that is 360 feet long and approximately 175 feet deep. This was one of the most difficult construction projects on the entire road.*[134]

Allatoona became a railroad town. Previously the area was a small farming community, but when gold was discovered in Auraria in 1839, there was a small growth in population because of the influx of prospectors.[135]

On his way to Atlanta, Sherman noticed Allatoona and Confederate general Joseph E. Johnston's stronghold on the Pass. He avoided the area on his initial move toward Atlanta.[136]

Johnston had to leave the railroad position to try to head off Sherman. As soon as he gave up the pass, Sherman moved in. He sent a message to

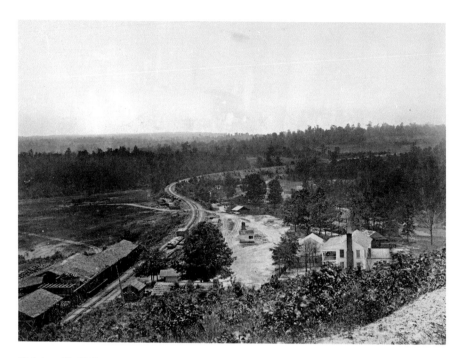

This is a Civil War–era southward view of Allatoona Pass. Today, the left side of this image is covered by Allatoona Lake. *Courtesy the Atlanta History Center.*

This is a view of Allatoona Pass from the south. The Clayton-Mooney House, at upper left, is still standing today. The railroad bed serves as the banks of Allatoona Lake. This photograph was taken after the Battle of Allatoona in 1864. *Courtesy the Atlanta History Center.*

French lost 897 men and Corse lost 706. French retreated to Alabama.[141] Sherman watched the smoke from Allatoona Pass on his perch on Kennesaw Mountain some fifteen miles away:

> *I watched with painful suspense the indications of the battle raging there, and was dreadfully impatient at the slow progress of the relieving column, whose advance was marked by the smokes which were made according to orders, but about 2 PM I noticed with satisfaction that the smoke of battle about Allatoona grew less and less, and ceased all together about 4 P.M. For a time I attributed this result to the effect of General Cox's mark, but later until the afternoon the signal-flag announced the welcome tidings that the attack had been fairly repulsed, but that General Corse was wounded.*[142]

Corse reported the next day of his injuries in a light-hearted manner, "I am short a cheek-bone and an ear, but am able to whip all h--l yet!"[143] The death toll on both sides was excessive despite the brevity of the battle.[144] The road ran red with blood. The bodies were so scattered it took three weeks to bury the dead. Bullet holes from the battle are still visible in the Clayton-Mooney House (built in 1840); this is the only structure in Allatoona from the war that stands today. The house served as a hospital, and bodies are reportedly buried around the house. The battle left such an impression on this tiny lost town that there was and is a grave to an unknown soldier.

Two stories have circulated about the unknown soldier in Allatoona, the remains of whom are located at the south end of the cut. One fact is known: in 1950, a grave was relocated from a place closer to the battle area. Railroad workers placed a stone and surrounded it with an iron fence. The railroad sign was erected, noting that this is an "unknown hero."[145]

FAST-FORWARD TO 1949

After the Civil War, Allatoona became a Confederate mecca. Groups would take rides on the famous locomotive "The General" from Kennesaw to Allatoona. Bartow County shares part of the Great Locomotive Chase story. Confederate veterans paid homage to one of the shortest and bloodiest battles of the Civil War while at Allatoona Pass.

Union brevet major general John Murray Corse's (*third from right*) visit to Allatoona Pass, the site of his Union victory during the Civil War, near the Western and Atlantic (W&A) Railroad (1886). *Courtesy the Atlanta History Center.*

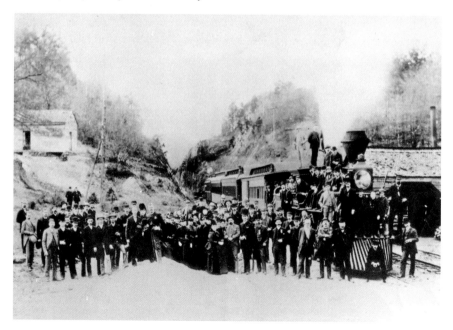

The International Association of Car Accountants with "The General," from the Great Locomotive Chase, Allatoona Pass, April 18, 1887. *Courtesy Vanishing, Georgia Archives, University System of Georgia, brt138-91.*

The story of the tiny town does not end with the Civil War. In August 1941 construction was authorized by the Flood Control Act to place a dam across the Etowah River to create a lake that would have seven purposes: flood control, hydropower generation, water supply, water quality, recreation, fish and wildlife management and navigation.

So, what happened to Allatoona and Allatoona Pass? It drowned. The track was removed from the pass; the railroad track bed serves as a levy

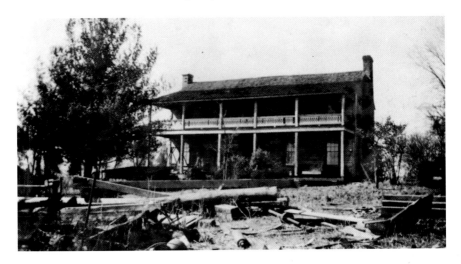

Allatoona once had three slave plantations; one was the Mooney-Clayton house. The house remains, while the town is at the bottom of the lake. *Courtesy the Atlanta History Center.*

This is a view of the now-drowned town of Allatoona, which was covered up by Allatoona Lake in 1949. *Courtesy the Atlanta History Center.*

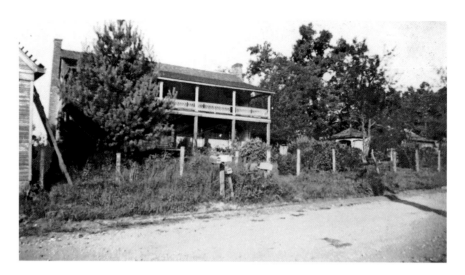

The Mooney-Clayton house is thought to have soldiers from the Battle of Allatoona Pass buried around the property. *Courtesy the Atlanta History Center.*

for the lake. Garland explains what happened to the track that went through Allatoona Pass:

> *Construction of the Allatoona Dam in the 1940's required relocation of the railroad from the Allatoona Pass and other track realignments moved the Etowah river bridge downstream leaving the stone piers unused, and also removed the McGuire's curve.*[146]

Work was delayed because of World War II and did not begin in earnest until 1946. The lake began to fill in December 1949, and the power plant began operating on January 31, 1950. According to the Lake Allatoona Association, "The Lake was full with 12,010 acres of water and 270 miles of shoreline."[147]

The town succumbed to water for a higher purpose. Allatoona Lake provides drinking water for most of Bartow and surrounding counties. During droughts, the remains of this lost town become visible. This haunting sight reminds us of what was sacrificed for our survival.

Part V

MILL TOWNS

9.

LINDALE, FLOYD COUNTY

If I could tell the story in words, I wouldn't need to lug around a camera.
—*Lewis Wickes Hine*

Norman walked with dread toward the stacks. Each step took him away from his mill home on Park Avenue in Lindale and away from school—his only way out of the mill. Each reluctant stride took a ten-year-old wrinkled boy to work. His place of work was the lint-choked spinning floor of the Massachusetts Mills. On this bright April day in 1913, Norman noticed a commotion.[148] Just outside the mill fence, the other doffers were talking to a man who appeared out of place. The bespectacled man was taking pictures and jotting down notes. Lewis Hine was busy setting up his tripod camera when Norman walked by with eyes focused downward. Hine called out to him.

"Can I take your picture?" Hine asked. Norman looked up. Hine knew he did not have the words to tell this boy's story when he looked in his disheveled eyes. Hine would have to let his camera lens do its job.

Norman was dirty before he got to work, and the sun was hurting his eyes, so he squinted as Lewis Hine focused his camera. The explosion of the ancient camera froze Norman Hall in time, dirt and all. The dirt highlighted the lines on his face, lines that belonged to a middle-aged man, not a ten-year-old boy. Hine asked Norman his name and age, and Norman replied, "Norman Hall, and I'm 12." Hine expected the standard lie and made a mental note to check the insurance papers. Hine could measure the

Investigative photographer Lewis W. Hine captured ten-year-old cotton mill doffer Norman Hall in 1911 in Lindale, Georgia, outside Massachusetts Mill. *Courtesy LOC, LC-DIG-nclc-02774.*

height of a child by the buttons on his vest and determine his age. He also could talk his way into the mill office and the mill floor.[149]

Norman told Hine that his father and brothers also worked in the plant and that he wanted to contribute. He said, "My parents said work never hurt a kid and I want to do my part. Plus we get to live in the company mill house, if we all work there."

Lewis Hine not only photographed the children who worked in the mill, but he also captured the mill homes. He would comment about the housing conditions, "Not a thing neglected, except the child."[150]

Hine's images would haunt the nation. In 1913, he worked with the National Child Labor Committee (NCLC), presenting the images to

Photographer and sociologist Lewis W. Hine took pictures and notes. He left this caption about Lindale's company housing: "Not a thing neglected, except the child." *Courtesy LOC, LC-DIG-nclc-02762.*

In contrast with Massachusetts Mill, Rome Hosier Mill provided mill hands with shacks. *Courtesy LOC, LC-DIG-nclc-02773.*

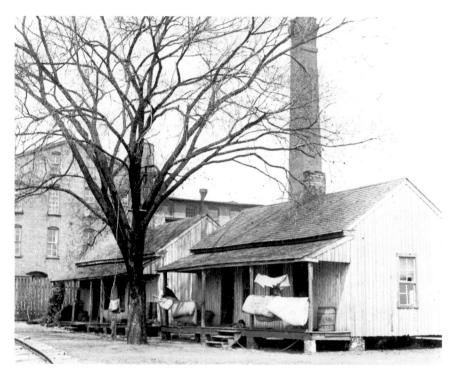

Above: In 1911, mill homes were often an improvement for families, but Hine described these run-down duplexes next to Floyd Cotton Mill as "the worst of any mills there." *Courtesy LOC, LC-DIG-nclc-02772.*

Left: While working for National Child Labor Committee (NCLC), Lewis W. Hine (1874–1940) photographed young spinners in Rome-area cotton mills. His images led to child labor reforms. *Courtesy LOC, LC-DIG-nclc-02770.*

Lewis Hine photographed Jo Veal, child laborer, outside Massachusetts Mill in Lindale. Hine used a simple technique of lowering the camera to capture the child's eyes. *Courtesy LOC, LC-DIG-nclc-02796.*

Hine hid a notepad in his pocket and took notes. "Tarlten [?] Gree, Lindale, Ga. Began at 10 years old in Massachusetts Mills. (Is now 13.) Doffs in Spinning Room #2." *Courtesy LOC, LC-DIG-nclc-02763.*

Ada Griffith, a very young spinner in Massachusetts Mill, ran four sides of a spinning loom. She twisted broken threads all day on the hot, lint-filled mill floor. *Courtesy LOC, LC-DIG-nclc-02786.*

A young girl works as a turner in Cherokee Hosiery Mill, Rome, Georgia. *Courtesy LOC, LC-DIG-nclc-02781.*

Photographer Hine recorded noon hour at Massachusetts Mill, Lindale. He said images were "more effective than the reality . . . in the picture, the non-essential and conflicting interests have been eliminated." *Courtesy LOC, LC-DIG-nclc-02758.*

Hine traveled America, exposing children in unsafe conditions at work. He said, "If I could tell this story in words, I wouldn't need to lug around this camera." *Courtesy LOC, LC-DIG-nclc-02757.*

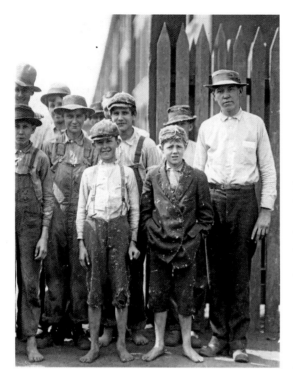

Left: Lewis Hine took many images during the noon lunch hour at Massachusetts Mill, Lindale, Georgia. He was not welcome in the mills. *Courtesy LOC, LC-DIG-nclc-02756.*

Below: Hine said, "I proved the ages of nearly a dozen of these children, by gaining access to Family Records, Insurance papers, and through conversations with the children and parents." *Courtesy LOC, LC-DIG-nclc-02753.*

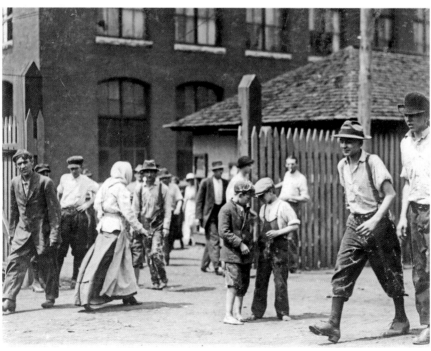

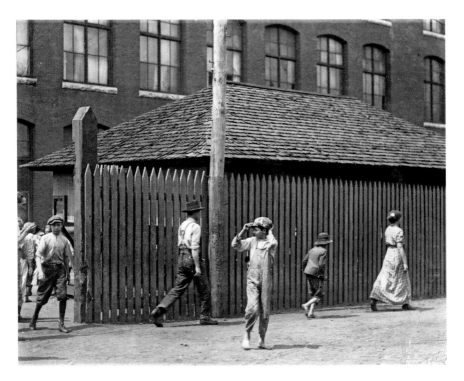

Mill bosses despised Hine, so he had to pose as an insurance agent, Bible salesman or the company photographer. He took meticulous notes. *Courtesy LOC, LC-DIG-nclc-02752.*

Congress. This led to solid legislation in 1938. The government began enforcing strict child labor laws.[151]

The loss of child labor was neither the end nor the beginning of Lindale. It was just part of the story.

LINDALE LAUNCH

Years before Lewis W. Hine came to Lindale, another social investigator came to town. Charles Barzillai Spahr got off the train at six, just before the mills' evening whistle blew. In 1898, the Lindale Mill Village was only two years old. The economics professor found his way to the boardinghouse to wait for the working adults to make it home. He was staying in the foreman's home. A young girl greeted Spahr, who had already prepared the evening meal of waffles.

Spahr wrote for *The Voice*, an influential religious publication interested in social change. His articles would later become a book on working people. He was there to see the conditions of the new textile mill. Lindale was the first southern textile mill Spahr examined. It became the focus of his chapter "The New Factory Towns of the South." Spahr viewed Lindale with a different lens than would Hine twenty years later.[152]

In 1896, Lindale was a farming community ensconced near the banks of Silver Creek in Floyd County. Massachusetts Cotton Mills moved in and began to build a mill village around the plant. The need for more workers forced the owners to build even more mill homes.

The first mill homes were wooden duplexes built with Boston-style high-pitched roofs. Later, roofs had a lower pitch because Lindale doesn't have Boston winter snows.

Behind each group of homes was a long, wooden outhouse. Each week "the honey wagon" would visit to empty the half-sized whiskey barrels of waste.[153]

Spahr found dinner conversation entertaining and educational. His host, the foreman, commented that he used to read Spahr's magazine, *The Voice*. He stopped subscribing, partly because of the politics and partly because of the religious views.

The men talked well into the night. They laughed at the poor-quality music filling the night air as the villagers unwound for the night. The foreman said, "There is more bad playing in this town than in any other place of its size in the country."[154]

The foreman described the religious community of Lindale to Spahr. He said there were almost as many church members as there were families. They all worshiped in the same building. The Baptists, Methodists and Presbyterians all shared the same meetinghouse. The foreman suggested that it might have been forced cooperation because the mill built the place of worship.[155]

The next day, the mill superintendent gave Spahr access to the workers. The writer was surprised at what he encountered upon meeting the mill children. Spahr said, "I knew before that children of 9 and 10 worked in these mills for 11 hours a day, and I expected that the sight of them working would quicken my rebellion against the system which robbed them of their childhood. But they went about their work with so much spring, and seemed to have so much spirit in it all and after it all, that I was completely nonplused."[156]

The writer continued, "It was all so far from being the conscious slavery I had expected that when I saw the superintendent I expressed

my surprise. He, I found, did not regard the child labor so lightly as the children regarded it."[157]

The Lindale superintendent wanted the younger children to go to school instead of working in the plant. He explained that few men over thirty-five years of age worked in the plant. He said the men married young, had children young and quit. When they got to middle age, they expected their children to support them. He tried to keep them out of the plant, but the fathers persisted. They wanted sons and daughters in the mills at the earliest age possible.

Spahr saw this fact supported while sitting in front of a grocery store just outside Lindale. At midday in Boozeville, a group of thirteen able-bodied men gathered as a blind man sang "On the Bowery."[158]

LINDALE LIFE

In the first two decades of the twentieth century, Lindale proved to be a boomtown. As production grew in the Lindale Mill, so did the need for workers. The mill built more homes. Men with families with the most children were hired first to fill the open positions in the mill. During this period, paternalism was a growing trend in mill communities throughout the county. Paternalism provided many nonwage benefits to encourage corporate community.[159] Lindale was no exception.

The company provided qualified and well-paid grade school teachers. By 1932, it had built a free kindergarten. The mill offered night school with transfer credits to Georgia Technical Institute. The schools were packed with children of large families still too young to enter the plant.

Guaranteed healthcare was a given in Lindale. Doctors were on staff and made house calls. A nurse lived in Lindale, and someone was on call all day and seven days a week. There was also a town dentist. The goal was to keep the workers healthy and productive.

In the early part of the century, the walk or even a buggy ride to Rome was an ordeal. So, Lindale had two department stores. Workers could use credit with payroll deductions. Grocery stores, as well as milk, egg, butter and vegetable deliveries, made Lindale a self-contained community. The company provided many of these nonwage benefits to keep the workers, or as the company called them, operatives, close to home. This paternalist system required a leader. So, to lead the operation or, maybe, control it, Harry Parris Meiklehram became "The Captain."[160]

The Captain

H.P. Meiklehram was the mill agent or plant manager from 1899 to 1937. He started a tradition in 1933 that continues today. One week before Christmas, Captain Meiklehram ordered workers to build a five-pointed wooden star. The "mill star" was 12 feet across and covered with tin. A crew hoisted the three-hundred-pound light-encrusted star between the 250-foot smokestacks. Every year since 1933, that same star has lit Lindale.

The Captain started many of the other Christmas traditions that exist to this day in Lindale. He used to say, "This is OUR Christmas." Some felt he was creating community, while others felt it was a way of controlling the millworkers. Daniel Scott Wilson grew up in Lindale and remembers the holidays. He writes, "Nothing happened in Lindale from the beginning that did not benefit the company." This was a subtle example of corporate paternalism. Wilson said, "I have found that most of the Christmas holidays as celebrated at Lindale served to help the company and not necessarily the people. Christmas in the cotton mill village was intended to keep the people under management's control. Paternalism created my Christmas. And it starts with the Christmas Star."[161]

The Captain may have created the mill star for more reasons than holiday cheer. In 1933, President Franklin Delano Roosevelt created the National Industrial Recovery Act (NIRA). This New Deal plan was to force prosperous industries to close one week out of the month. This gave the suffering mills a chance to catch up. As a result, Lindale shut down and cut employee wages. Things got tight for the Lindale employees, especially at Christmas. The Captain may have had the star placed to foster community and good will. It worked.

Loyalty was important to Lindale workers. In 1934, textile workers across the South revolted against evil mill owners. Lindale did not revolt; instead it wanted management to save them from the evil federal government. Lindale millworkers felt protected during the Great Depression. In 1935, the U.S. Supreme Court struck down the NIRA.

Wilson said, "The star was a symbol of hope for the employees to look toward during the hard times of the Great Depression. He hoped the star would draw people to the village—just as the star brought the three wise men to the birthplace of Jesus."[162] The Captain may have seen it as another way to manage the lives of the operatives in Lindale.

THE 1940S AND 1950S

Pepperell bought the Lindale Mill. The company built Pepperell Junior High School to expand education for the mill children through the ninth grade. Mill owners encouraged children to stay in school and stay out of the mill. They continued to subsidize teachers' pay.

Built in 1940, the Lindale Auditorium became the social hub of the town. The large multilevel brick and stucco building had a manicured lawn. The auditorium housed a theater, barbershop, billiard room and sandwich shop. The food was cheap. A hamburger was a nickel, and a shake was a dime.

In the basement of the Lindale Auditorium was a tiled and heated swimming pool. It cost a dime to swim. The indoor heated pool was unusual for the time; it was the only one in the region.

Sundays saw a Bible study in the morning and a movie in the afternoon. Movies were a dime for children under twelve years old, then the price went up to a quarter. Everyone knew everyone, so no one could cheat their way in and say they were younger than twelve if they indeed weren't. Sometimes the Lindale Band would play in the park on Sunday afternoons.

Baseball was a favorite pastime in all southern mill towns, and Lindale was no different. Lindale had a top-notch field; in fact, other teams preferred the town's field. On game day, the mill would close in time for the people to support the Lindale team. Management gave key players Mondays and Fridays off to rest for weekend games.

World War II provided textile contracts, keeping the mill running three shifts. Pepperell supplied the armed forces with all the textiles they needed. When the men left for war, the women took over. When the war was over, the mill honored the veterans and remembered their dead. Residents took care of one another during the war, and the mill town continued to prosper.[163]

Wounded soldiers from the Battey General Army Hospital came to Lindale Auditorium for movie night. A Rome bus ran a route on the weekends. Many wartime romances started between Lindale women and lonely soldiers on movie nights.[164]

Southern Railroad had a full-time staff at the Lindale depot. Each day a train ran from Chattanooga to Atlanta and back again in the evening. Each way, the train stopped in Lindale to deliver mail and parcels. The post office, located in the back of the company store, brought that mail to military wives.[165]

Good feelings about Lindale prevailed. Longtime residents felt it was a good place to work, with good pay and no layoffs. Billy Atkins and Jim

Givens grew up in Lindale in the 1940s and called it "a utopia south of Rome."[166]

When the war ended and the men returned home, things began to change in Lindale.

Changes

The law required that the men returning to the mill could have their jobs back. Many came back, but some did not. Having experienced the world, some men chose to look for new opportunities. The GI Bill allowed families to stop renting the mill homes and move outside Lindale. The road to Rome became populated with GI Bill homes.

Pepperell followed the trend of many mill towns and began selling the mill homes to the employees. Most of the employees bought the houses. The mill was no longer responsible for the maintenance of the homes. Neglect crept into the community. As a result of this, a series of events was set in motion.

Soon the company store and the post office closed. The old school closed when another one was built outside Lindale. Even the beauty shop closed. Southern Railroad stopped its daily runs and demolished the depot. The textile leagues no longer played on the company baseball fields. When gas was no longer rationed, people left Lindale to show and find entertainment. They no longer relied on the Lindale Auditorium for their sole place of recreation.[167]

The textile industry changed, and production slowed. When the mill went on "short time," people began to find employment elsewhere and moved away. The loyalty was gone, and paternalism was a thing of the past. In the past, the company employed entire families and took care of their homes, healthcare and entertainment. Now the company would no longer be the "father figure." The village began to lose its way.

Lindale Lost

Richard Wolfe came to Lindale in 1977 to close the mill. West Point Pepperell told him not to move his family because he would not be there long. When Wolfe got to Lindale, he saw potential not only in the mill but also in the people. At the time, there were 2,200 mill employees.

In 1965 West Point mills merged with Pepperell. Greenwood Mills then purchased West Point Pepperell in 1986. Richard Wolfe understood the people in Lindale. He grew up in a mill village in LaGrange, Georgia, and he was one of them. As the new vice-president, he could not stand the thought of putting that many people out of work. Wolfe made a plan to save the mill by tapping into the burgeoning denim market.

The corporate office took notice and gave Wolfe permission to spend on capital improvements. They changed the plant into a top indigo denim producer, selling one million yards a week to top jean makers. By the 1990s, Lindale was a world-class operation. Wolfe went to Venezuela in 1990 to build another denim operation for Greenwood Mills. Then the denim market crashed. Lindale succumbed.

Greenwood Mills cut production in 1999, keeping only the dyeing and finishing departments. Little by little jobs evaporated. Then on September 28, 2001, at 3:00 p.m., the final whistle closed the plant for good.

Richard Wolfe had retired in 1996, but not before giving Lindale several more years of productivity. He repurposed the mill and built a market to give the residents years of income. The community honored Wolfe by dedicating a park to him. The Richard Wolfe Park will provide green space in Lindale for generations to come.[168] It remains today, across from the crumbling Lindale Mills.

ALL IS NOT LOST

Lindale as a mill village is lost to history. Working-class people still live in the mill homes. The Lindale community tried to save the mill and find a new purpose. Companies have come in and salvaged the textile equipment. Others have repurposed the floors and the bricks. As the building gets smaller, one thing has remained: the community's resolve to restore.

The evidence is all over town, pleading citizens to "Restore Lindale." Studios are filming in the mill. The Bartow History Museum restored the original courthouse with wood flooring from the mill. A house in Atlanta used mill bricks from the crumbling walls for its new walls.

Some traditions are dyed into the fabric of Lindale. There are some things so important to a community that they must go on. The Lindale Star Association is trying to save the mill star, the tradition and the fate of the smokestacks.[169]

Each November a group of volunteers raises the 1933 mill star between the stacks. The mill is crumbling around the smokestacks, but the star continues to shine. The Lindale Mill star outlived the company that created it.

10.

ATCO, BARTOW COUNTY

Industry suffered in the South during Reconstruction. Henry W. Grady was a journalist and speaker who pushed for the re-industrialization of the South. After working in New York as a reporter, he returned to the South and became an editor of the *Atlanta Constitution*. He bought the newspaper and built its circulation. He was more than a newspaperman. He is credited with influencing capitalists to move the entire textile industry from New England to the South. The American Textile Corporation (ATCO) and later Goodyear is a direct result of the new mill town movement.

After the Civil War many poor whites looked for employment in mills, but the industrial revolution did not reach the South until the 1880s. Every town wanted its own mill. Tenant farmers were looking for a new life, but they needed low-cost housing in order to move off the farm.[170]

In 1904 ATCO built homes for its workers. Dubbed as one of the most modern mill villages, ATCO built over two hundred homes just outside Cartersville. This was an extension of the mill into the life of its operatives, an example of industrial paternalism. Paternalism was practiced as a way of keeping workers productive.[171]

Paternalism was also a way to attract working families into the mill village and foster loyalty to the company. Nonwage benefits—including schools, low-cost housing, life insurance, savings plans, company stores with credit, recreation facilities, bands, sports teams, nurses and doctors—were all part of the paternalist system in southern mill towns.[172] Atco became this kind of town.

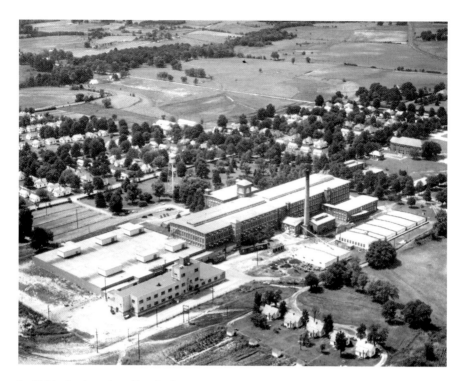

In 1904, the American Textile Company (ATCO) built 40 homes for workers; the number grew to 297. The company began selling off the homes in 1959. *Courtesy Bartow History Museum.*

BRIEF HISTORY

Edward McClain was making horse collars in 1903 in Greenfield, Ohio. He needed a cheaper way to make the cloth to pad the collars. He bought six hundred acres north of Cartersville to build a textile plant. The property borders Pettit's Creek, Nancy's Creek, old Highway 41 (now GA Highway 293 or Cassville Road) and the Western & Atlantic Railroad (now CSX). The plant was completed in 1904. (At the date of this writing, there is very little left of this original building. There is, however, a wall with the date "1902" clearly embedded in the brick.)

McClain had bad timing; the automobiles became more popular than horses, and he tried to retool as the market changed. In 1929, Goodyear purchased the plant and village to make cotton tire cord. The company and the community thrived. The village grew to 291 homes, and the older homes were modernized. Atco had the reputation of being a beautiful and modern mill village.[173]

116

LIFE IN A MILL TOWN

The American Textile Corporation created a self-sufficient town. Atco had an icehouse, church, store, fire and police department, water, swimming pool, baseball field, parks, laundry and barbershop.

Cartersville native Jan Lanier remembers visiting her friend in the summer and swimming in the Atco pool. While playing in Atco, Lanier was hurt, and she was sent to the Atco nurse. This was everyday life in Atco, Georgia. The mill town took care of its guests and residents.

The company maintained the homes. Jodie Hill remembered:

> *It was a really attractive village. It was the most immaculate place, more than Cartersville itself. It had to be in perfect shape or you wouldn't live there. The company demanded it. As a matter of fact, they were responsible and paid for the upkeep of all the lawns, shrubbery, and the painting of houses. The houses were painted every other year. We had our own water. We did not use Cartersville city water. It was a little city and we had our own post office at Atco.*
>
> *The company furnished the water, drilled its own wells and that time it was unheard of. We had good cold water all the time. Anyway, it was through the village and there was no charge for the water. The electricity*

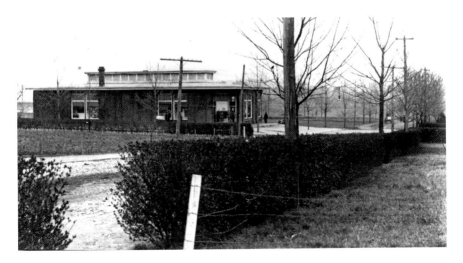

The "company store" is seen here in 1920. Goodyear purchased the store in 1929 and started issuing coupons that workers used to purchase items. Sometimes credit accounts were set up, and purchases would be deducted from workers' paychecks. *Courtesy Bartow History Museum.*

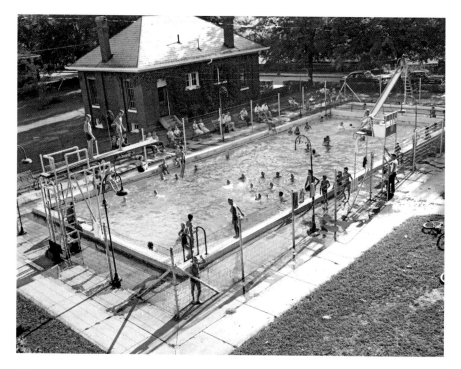

This spring-fed pool was built for ATCO millworkers and their families. This photograph was taken in 1955. *Courtesy Bartow History Museum.*

was furnished by the company but we paid for it, the whole amount of twenty-five cents per room.[174]

Atco was more than a plant or a mill community; it was home to many people, who continue to connect, especially on social media. The Atco "family" started early. According to a *Rome News-Tribune* writer, when E.L McClain built American Textiles Company on four hundred acres inside Cartersville, he built a village. The 40 homes expanded to 291, and the feeling of community grew as they worked together and played together. McClain began this by creating a beautiful place for his workers to live. The Atco homes were not row houses, as were many mill villages of the time. According to the newspaper's *Past Times* historical magazine, each home was different. "There were different sizes and styles from New South and Queen Anne cottages to Craftsman bungalows and old Victorians with three to seven rooms each." The homes were an improvement, considering the workers came from farm homes with few amenities. The mill homes had electricity, water and indoor toilets. In the beginning, the average

worker made two dollars per day and paid one dollar a week in rent. The neighborhood grew in 1927 to 291 homes as Goodyear took over, providing even more "luxuries" for the working families.

Wagner reported from the National Register documentation, "The village was a vital part of the mill's operation, providing a total living environment for its employees. It was believed that this in turn would lead to greater productivity."[175] The company added a post office to the store, a community building with a gymnasium and meeting room, a barbershop, a laundry and an icehouse. There were two churches and playgrounds, a swimming pool and a baseball field. The company had a baseball team that played other mill town teams. One of the players went on to play for the Detroit Tigers.

Rudy York (1913–1970) worked in the ATCO mill as a teenager and played on the company's baseball team. He played in the farm leagues and, in 1933, signed with the Detroit Tigers at the age of nineteen. He played

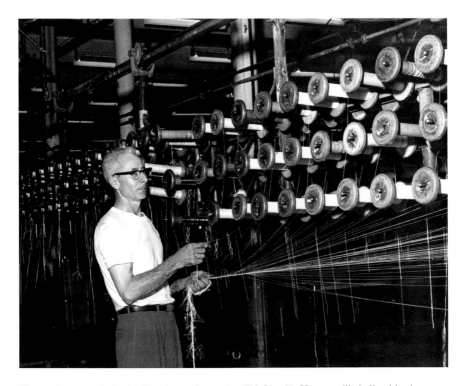

Homer Long works in the Goodyear (formerly ATCO) mill. He most likely lived in the community. The village had everything the families needed. This photograph was taken around 1950. *Courtesy Bartow History Museum.*

in the majors from 1937 to 1945. York broke Babe Ruth's record for most home runs in a single month.[176]

In addition to a major leaguer, a governor came out of the Atco community. Joe Frank Harris, a two-term governor of Georgia (elected 1982 and 1986), was born in Atco on February 16, 1936. His parents moved into Atco in the 1920s from Gilmer County to find work in the mill. He talks about life as one of the "Atco boys," even after his father left his job at Goodyear.[177] Harris reported in an oral history that he considered himself a rural politician, as he grew up in Atco/Cartersville.[178]

Things Change

Like many manufacturers of the era, mill village homes were sold to private owners in 1958. The City of Cartersville annexed Atco on December 2, 1957. The post office closed. Goodyear, like many mills at the time, began selling the houses. Atco was no longer a mill village, but the sense of community remained.[179]

In 1929, in cooperation with Bartow County Schools, Atco and, later, Goodyear built and operated the school serving grades one through eight. The school was subsidized by funds received from the State of Georgia. In 1957, Atco became part of Cartersville. The Atco School closed in 1963.[180]

On October 1, 2003, Goodyear closed the mill doors in Atco, leaving the remaining 319 employees out of work.[181] According to the *Rome News-Tribune* writer, an effort was made to list the mills and homes in the National Register of Historic Places beginning in 2002. Atco won the designation on October 21, 2005. Some of the images in this book come from the Bartow History Museum and were used to win the listing.[182]

The plant is slowly disappearing; what remains is a shadow of a productive industry. All that remains today is a precarious water tower and the last pieces of a mill that bears its birthdate of 1904. With everything else torn down around that section of the old mill, that one section is resistant to the wrecking ball. It is reluctant to go.

11.

CHICOPEE, HALL COUNTY

I wish I could travel back in time and see what so many have described of this magical place nested in Hall County, Georgia.

—*Kris Rogers*

"Chicopee, I will never forget you."[183] This is one of many comments left on the Kilmer House website. The Johnson & Johnson archival blog gives a glimpse into life in a North Georgia mill village, beginning in the 1920s and continuing for years, even after the mill had closed. Other comments support the rumor that life in Chicopee was good. One person wrote, "I loved my life there." Another said, "I still live in Chicopee Village. My grandson is the 5th generation of our family to grow up living in Chicopee, Georgia!" The praise continued: "Those of us who are fortunate enough to call Chicopee our home will never forget how blessed we were to be a part of something so special. I think the best memories for us will always be about the wonderful people who lived in the village."

The comments also mentioned the Johnson & Johnson Company. For example, "I was proud to be a member of the JNJ family of employees." Another said, "We have a tremendous history thanks to Johnson and Johnson." Another commenter recalled, "For many of us it was the best time of our lives provided for and by Johnson & Johnson Enterprises."[184] One who wished she had experienced Chicopee Village said she lived in Gainesville for years and never knew Chicopee's history until she stumbled upon the Kilmer House website. She wrote the following:

Have we as humans forgotten the true meaning of life and what a family is? Not only blood relatives but our extended family—our community. I wish I could travel back in time and see what so many have described of this magical place nested in Hall County, Georgia.

I am amazed. I want to live in such a place. Working in real estate, one day I want to develop a community like Chicopee, looking very forward to such a day. I will always remember this website and how it has changed my very life this day. Reading about this amazing history on your website—it just changed my life forever.[185]

What is the reason for such passionate praise of a mill town community? Nostalgia? Maybe these commenters were remembering as a child does, leaving out the bad parts? Maybe this one manufacturing community learned from the mistakes of an earlier phase of paternalist mill towns and did it right. The secret to Chicopee, this unusual mill village, was the man who designed it, the company that built it and the people who filled it.

WHAT'S SO SPECIAL ABOUT CHICOPEE?

In 1925 the vice-president of Johnson & Johnson was looking for a place to expand its medical-supplies business from Chicopee Falls, Massachusetts. Robert Wood Johnson Jr. walked the North Georgia wooded hills outside Gainesville, Georgia, and bought the acreage he needed to build a textile mill and workers' homes. Chicopee Village was born. Although the town never incorporated, Chicopee was a close community.[186] Johnson wanted something different from the grimy mill inn in Chicopee Falls, Massachusetts, so he started from the ground up.

The new Chicopee mill was a one-story affair with open spaces flooded with light. Most textile mills were brick and multi-storied, with a few dingy windows. The new Chicopee plant looked like a college campus. A modern mill deserves a modern and well-designed village.

In the 1920s, the industrial South was crowded with one thousand cotton mills. Most of the mills had a mill village with substandard housing with no insulation, dirt roads and outhouses. Johnson & Johnson wanted to do things differently from the usual mill design; its homes would offer employees a clean, modern place to work within a planned community. According to an oral history recorded in the archives of the University of North Georgia:

The mill itself was designed by J.E. Sirrine and Company and was built by Fiske-Carter Construction Company, both from Greenville, South Carolina. Fiske-Carter also built over 200 homes for the mill employees. There were 31 layouts the employees could choose from, and the neighborhood was landscaped and planned by E.S. Draper of Charlotte, North Carolina.[187]

Earle S. Draper made his living designing villages for southern textile mills. He drew inspiration from the land and the lives of the millworkers. Chicopee Village would create an urban garden city with a rural twist. His work for the company town would easily adapt to the social and economic guidelines of New Deal regional community planning, which would come within years of building Chicopee.[188]

He built towns that had curving, flowing streets and homes on lots that were spacious enough for the family garden. Draper believed that he must serve the needs of the company operatives. This was the new mill village phase of the 1920s industrial era.

Draper was a successful town planner and mill village designer when Johnson & Johnson called on him to create a community out of the rolling hills and red clay of Northeast Georgia. From the beginning, the company was going to do things differently than other southern textile manufacturers.

Draper insisted that the village be placed across the street from the mill, with a stand of shady trees as a buffer between work and home. Most mills were the center of the mill community, but this one was different. The design was to give laborers or operatives time away from work. Always ahead of his time, Draper insisted the company buy more property to add a large swath of land as green space buffering village from encroachment.[189]

THE MODERN MILL VILLAGE

The northern namesake of Chicopee Falls, in Massachusetts, was a town filled with textile mills and other plants. The factory workers lived in row after row of desperate tenement homes.[190] The 250 homes built in Chicopee were not constructed like the homes in the Massachusetts Falls mill town. The homes were not laid on a grid; instead, Draper left a certain percentage of wooded area and green space. According to Margaret Crawford in her text *Building the Workingman's Paradise*:

Chicopee, Georgia

A FIVE ROOM HOUSE IN CHICOPEE VILLAGE

Johnson & Johnson built thirty-one varieties of these Chicopee Village brick homes in 1926–27. *Retrieved from Johnson & Johnson Archives and the Kilmer House.*

In Chicopee, Draper recreated a microcosm of the Piedmont landscape. This began with a search for the correct site. Avoiding the flat, red fields preferred by plan engineers and surveyors, Draper selected a sloping and irregular site, readily available in a region of hilly uplands. He preferred wooded sites and retained stands of second-growth timber whenever possible.[191]

Houses were placed to match the terrain. Trees were saved during construction to create an old-growth community.

Village homes were built from thirty-one different designs. Though Draper did not design the house plans, he insisted on quality and variety. Each brick home was state of the art. Each had indoor plumbing, electricity, hot water and brick fireplaces. When most roads were still dirt, Chicopee

Chicopee's designer, Earl S. Draper, created a community identity separate from the gauze plant across the street. *Retrieved from Johnson & Johnson Archives and the Kilmer House.*

Village had paved roads and sidewalks, as well as a sanitary sewer system and storm sewers. The company built a water filtration plant to provide pure, filtered water to the community.

An innovation that set Chicopee apart was the underground electricity and steam pipes beneath the homes. The tunnels that carried these utilities to the village and the mill are still beneath the ground around town. A fiftieth-anniversary pamphlet printed by Johnson & Johnson stated:

> *The electric street lights (were) of the latest and most ornamental type with no unsightly wires overhead. All village wiring (was) underground . . . in this way they cannot be short circuited or blown down by storms. Their concealment, moreover, improves the appearance of all streets and houses.*[192]

ALL WORK AND NO PLAY

As labor laws forced plants to limit work hours to fifty per week, workers had more time for leisure. Draper designed many common areas for community recreation. One former resident remembers, "Big steel, green glider swings in the grass next to the highway, great on a Sunday

afternoon." They rode bikes, roller-skated and fished. Chicopee was a safe environment.[193] The village sponsored dances and movie nights in the community center. Behind the center was a swimming pool and tennis courts. The community had sports teams and an athletic field. The community was designed for recreation, with parks and manicured places. The hidden utilities and the town's natural design added to the leisure ambience of Chicopee Village.[194]

FRESH CLEAN COTTON SMELL

Melinda H. Gravitt lists remembrances of life in Chicopee Village: "[My] Mother doing laundry with old wringer washing machine then hanging clothes on line in backyard. Oh, the sweet smell and feel of those sheets that had hung in the sun all day!"[195]

Gravitt also remembers the focus on cleanliness and health when Johnson & Johnson owned the village. "Houses were inspected by company for cleanliness, painted inside and outside on schedule by company and they even furnished our light bulbs!"[196]

The company had rules for living in the community and distributed a list of village rules to the residents. The rules were enforced by the company nurse, who made regular home inspections. These rules were salvaged from an original Chicopee document:

> *Household Regulations:*
> *Keep wash basins, bath tubs and water closet clean. (Special brushes are provided for this purpose.)*
> *Keep your cook stoves and ice boxes clean.*
> *Keep walls and ceilings clean in every room.*
> *Keep porches clean.*
> *Keep screens in windows through the summer.*
> *Report at once any trouble with the lights or plumbing.*
> *Keep grass on lawns cut, and ground around house clean and free from rubbish.*
> *Do not allow garbage or ashes to collect upon the premises. Put them in the cans provided for this purpose. These cans will be collected and their contents disposed of daily without charge.*
> *Do not waste water and electric current. Turn off all electric lights, water faucets and electric stoves or heaters as soon as you are through with them.*

Follow all directions of visiting nurse when she makes her regular inspections
of the premises.
Village Regulations:
Keep sidewalks swept.
Help to keep all streets, parks and playgrounds clean. Do not scatter papers
or other rubbish on any part of the property
Never park an automobile in front of a fire hydrant.
Do not tamper with fire hydrants or the village telephones.
Do not damage trees, shrubs, roadways, or any other public property
Cows, mules, horses and goats must not be kept upon the property and
household pets must not include a vicious dog or any other animal, which
can menace or annoy your neighbors.
Know where your children are and what they are doing when not in school
or in charge of a director at the playgrounds.
Use village telephones to instantly report an outbreak of fire.
Report immediately to the trained nurse in every case of sickness.
Report all public nuisances, disturbances, and violations of the law to the
Department of Public Safety.
Use village telephones to report accidents. [197]

Health, safety and well-being were primary concerns; the company archives contain books and pamphlets about these topics. Gravitt remembers the quality of the healthcare provided by the company: "[I remember] lining up in the hallway at school for vaccinations. Free to us and given in the library by the company nurse." The clinic, the nurse and the doctor were always available for cuts and bruises and more serious ailments, free of charge.

The mill operated within progressive safety standards, such as an automatic fire sprinkler system. The village had the latest in safety, such as the telephone relay system for residents to report emergencies. Johnson & Johnson was even concerned about water safety. [198]

The company was also concerned for the community squirrels. Ms. Gravitt remembers, "Miss Bessie Bickers, founder of the Hall County Humane Society, coming to school each spring to talk mostly to the boys urging them to please don't use their BB rifles to shoot birds and small animals." [199]

Something Old and Something New

After the New Deal era and World War II, the industrial trend was to sell off company homes. Johnson & Johnson followed that trend. The beautifully designed homes in Chicopee Village were sold to the occupants in 1959 for $1,000 per room. Even though the company outgrew industrial paternalism, the community remained committed to one another. The citizens had forged a bond and continued to care for one another. Instead of the community decaying, it was preserved. Residents remained close to one another and to the land.[200]

When Johnson & Johnson Company purchased property to build the Chicopee Mill and Village, it was part of the Walnut Creek watershed. When the company cut production in the 1970s, it closed the water filtering plant. The community was now getting municipal water. The company donated nearly 3,000 acres of the watershed to the Gainesville Area Park Commission. Elachee, a nonprofit already working on preservation education, was asked to consult with the commission. The 2,674-acre green space was reserved for recreation and preservation. The Chicopee Woods Area Park contains a public golf course and an agricultural demonstration pavilion, and 1,400 acres are preserved in the center of the park for the Chicopee Woods Nature Preserve, under the management of Elachee.[201]

In 1994 the plant was sold to S.I. Corp., a Tennessee-based company that produces fabrics for trampolines and swimming pool coverings.[202] New businesses occupy the plant, such as a recycling company. Plans to bring even more new business (a brewery) to the old plant circulate, but Chicopee Village is a settled community that remains well loved. In a 2012 *Gainesville Times* article, a current resident commented, "It has that sense of community that I haven't seen anywhere else." Another resident said, "I love living here. . . . It's old, it's funky. If I could pick it up and drop it down in Virginia Highlands (in Atlanta), it would be worth $400,000."[203]

Though the original purpose of the community is lost to industrial history, the heart of Chicopee Village continues to grow. Land once set aside for green space for the villagers by Johnson & Johnson now is Elachee in the Chicopee Woods, preserving and educating future generations. Industries continue in the old gauze textile mill with new-age ingenuity. Of all the lost towns, this one seems to have held on and grown at what matters—community. The secret to this success may lie in the man who designed the village to work with the land and encourage well-being.

Maybe it was that Johnson & Johnson committed to do something different than was down in the town's namesake and to create a home for the workers instead of tenant shacks. It was both the design foundation and company ethos that contributed to the birth of a community. And it was the people who made it work. They continue to make it work.

12.

SCULL SHOALS, GREENE COUNTY

In this serene natural beauty, the ruins of brick walls, lonesome chimneys, and granite foundations mark—like tombstones—the final resting place of the commercial ambitions of this intriguing, history laden site.
—Robert Skarda

AN ENCOUNTER IN THE SHOALS

The woman splashed into the muddy waters of the Oconee River, clutching her five-week-old while trying to stop the bleeding from her breast. The Creek Indian who had fought, scalped and murdered her husband was after her and her slave girl. They had chopped at her arms, making holding her baby a conscious struggle. The current was stronger than usual, and in her weakened state, the unspeakable happened—she dropped her infant bundle.

She clawed and dug in the water, trying to recapture her baby, but the current had taken the bundle. She screamed, and they found her. The enemy Creeks caught up to the woman and her slave and finished what they started, leaving them to float away down the river.[204]

Richard and Mary Thrasher and their two children were murdered in Scull Shoals in 1793. This event was recorded in a document found in the Georgia Archives:

Personally appeared Mical Cupps and on oath saith that he was near the Oconee river on Monday the twenty second of this Inst. And hear a gun on the opposite side of the river and immediately saw thirty Indians fireing upon and massacreing (sic). Richard Thrasher, two children, and a Negro wench, at the same time, the wife of the deceased, with an infant of about five or six weeks old run, and leeped into the River, the Indians fireng upon her as she fled, the woman was found a live, scalped, wounded in both her thighs, her right brest, with Balls, and, stabed in her left brest with a knife, her left arm cut nearly off, as is supposed with a tomahawk, of which wounds she died, in about twenty four hours, the infant was found drowned, a small distance from the mother, without any marks of violence upon it.

This deponent with others pursued the trail of the Indians about two Miles, and found from their tracks, that, there were thirty seven in Number, further this deponent saith not.[205]

Citizens and the militias were afraid of all out-war with the Creeks, and they asked Georgia governor Edward Telfair for protection at Scull Shoals. They turned to veteran Indian fighter Major Elijah Clarke. He dispatched Phinizy's Dragoons to the Scull Shoals station. There, they built a fort to protect the citizens of Scull Shoals. A drought and broken treaties brought on hostilities with the Creek Indians.

Hostilities had increased as the government failed to keep treaties. Drought hit both Creeks and whites in the summer of 1792, crops had failed and the government failed to ship grain to the Creeks. The local friction between the natives and whites resulted in unprovoked Indian attacks, like the one recorded in April 1793 in the *Augusta Chronicle*: "In Green County, on or near the Scull-Shoals on the Oconee River, on Monday last, at ten in the morning six person, a man, woman three children and a negroe [*sic*] were murdered by a party of Indians."[206]

THE UN-SETTLING OF THE SHOALS

Even the name is disturbing: Scull Shoals. On old maps, the name of the town was Skull Shoals. One story about the origin of the town's name is found upriver. The nearby ancient Indian mounds has human skeletal remains. At one point a heavy rain caused those remains to wash up on the

riverbanks. Nice story, but the truth is in the definition of the word "scull." A scull is a type of oar, as well as the method of rowing that allowed boats to pass the shoals in the river.[207]

The story of Scull Shoals begins with the Creek Indians. The Creeks and the Cherokees lived in North Georgia before the Revolutionary War. The Creeks were divided in their loyalties and stayed neutral. After the war, England gave Creek land to the United States.

"Headright" was a rudimentary system of granting lands to able-bodied men dating back to the early 1600s in the Virginia colony. Georgia passed a number of headright laws, but it was in 1782 that headrights were granted to anyone who fought in the Revolutionary War. Georgia was dealing with Creek and Cherokee Indians, and the headright system seemed to be the perfect solution by providing a land buffer of farms.[208]

The first landowner in the Scull Shoals area was Henry Wagner, whose deed was recorded in 1784. Within three years more than twenty others made their homes in the shoals. Many of the newcomers were former residents of Virginia. So many, in fact, that the people of Scull Shoals were often referred to as "Virginians."[209]

White settlers cleared the land for the logs they needed to build rudimentary cabins and farming, but also for protection from the Creeks. Skarda says, "Planters disliked leaf litter, pine straw and nut mass on cultivated plots and ordered the land stripped to keep the cotton crops free of debris. Cleared plots also allowed overseers the ability to keep an open line of sight to their slave teams tending the all important cotton crops and farm chores."[210]

After years of Creek battles with white settlers, Georgia authorities met with the Great Creek chief in New York City and signed away the land east of the Oconee River. Back in Georgia, the whites were displeased with the confinement of the treaty. The treated prohibited whites from even crossing the Oconee River without documented permission.[211]

THE GHOSTS OF MANUFACTURING PAST: THE PAPER MILL

Scull Shoals is hard to find. It has always been hard to get to. The train never came to Scull Shoals, and the roads were dangerous and often hard to navigate, especially when it rained. After rains, erosion made navigating the

Oconee difficult. Any industry in Scull Shoals had so many factors against it from the beginning.

The *Georgia Express* on December 15, 1810, announced that the state legislature granted Mr. Zachariah Sims a loan of $3,000 to open a paper mill on the Oconee River.[212] The paper mill was a good idea that lasted only five years. In 1815 Sims went bankrupt.[213]

THE GHOSTS OF MANUFACTURING PAST: FONTENOY MILLS

Dr. Thomas Poullain purchased the abandoned paper mill and built a thriving cotton mill that he led for forty-one years (1827–68). According to the Friends of Scull Shoals, during this time, "There were flourishing mills, boarding houses, stores, a large warehouse and store combination, a distillery, a toll bridge, and other enterprises."[214] When fire destroyed the wooden mill buildings in 1845, Poullain financially supported his millworkers as they rebuilt the structures of Fontenoy Mills in brick. They were back in operation by 1846. According to history from the Friends of Scull Shoals, "In 1854 Poullain had 2,000 spindles and looms, consuming 4,000 bales of cotton valued at $200,000. It was clearly an economically productive enterprise. As the enterprise expanded, more than 600 people were employed to make yarns and cloth."[215]

After surviving the Civil War, the mill experienced droughts and devastating floods, causing work to stop. There was either too much water or not enough—a major issue for a facility run by waterpower. A major flood in 1887 left water standing in the building for almost a week. The covered toll bridge floated away. Hundreds of bales of cotton were ruined in the mill. Food was wasted. This event brought economic chaos to Scull Shoals Mills from which it never recovered.

One hundred years of open-field cotton farming caused erosion that removed eight to nine inches of topsoil from the fields. It was deposited in the rivers and covered the shoals. This, in turn, caused more frequent flooding, which continues to the present. Heavy siltation cut the "head" of water needed to power the mills, often stopping millwork.[216]

By 1900, most people had left the mill for work elsewhere. The Fontenoy mill closed forever. During World War I, machinery was scrapped, and most of the plant was dismantled. The bricks and materials were repurposed.

Today, only three walls of the brick warehouse and store remain, along with the arched brick bridge that took workers across the raceway into the mills. Stone foundations of the old mill's power plant and scattered stone and brick chimney bases can be found in the downtown village and in the surrounding woods. Remains of the wooden covered toll bridge stand in the Oconee River.

Between 1875 and 1930, the town's land was divided and sold several times. In the 1930s tracts were reassembled by R.P. Brightwell of Maxey's and sold to the government for an experimental forest. It became a teaching laboratory for the University of Georgia's School of Forestry. The Soil Conservation Service and Civilian Conservation Corps also did massive reclamations, terracing eroded hillsides and replanting the forests.[217]

Scull Shoals became part of the Oconee National Forest in 1959. Robert Skarda, in his book *Scull Shoals: The Mill Village that Vanished in Old Georgia*, describes what remains:

The entrance to Scull Shoals. The shoals became part of the Oconee National Forest in 1959 and is open to the public. *Photography by Douglas Boyle.*

The rock foundation of the Fontenoy Mills power plant in Scull Shoals is seen here. This image illustrates the destructive power of water. *Photography by David Byers.*

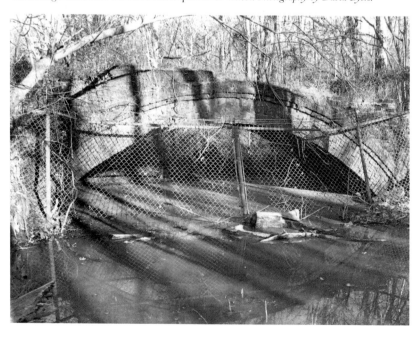

The arched Scull Shoals Bridge once took the millworker across the raceway to the mill. Most of the town has eroded away. *Photography by Douglas Boyle.*

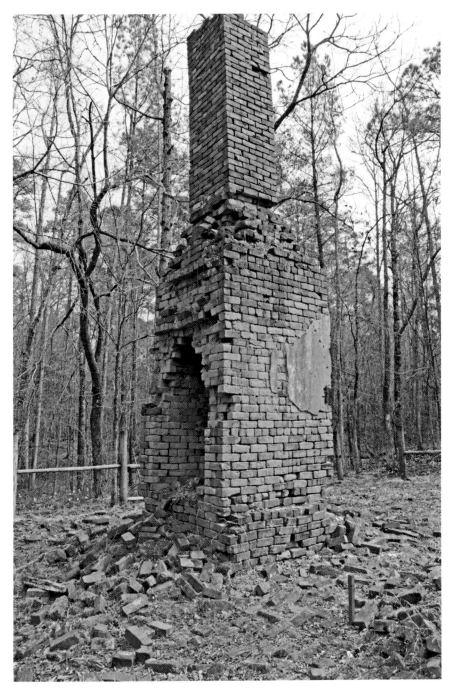

Scull Shoals once had an unsuccessful paper mill, but for forty-one years (1827–68) Dr. Thomas Poullain ran a prosperous cotton mill and village. *Photography by David Byers.*

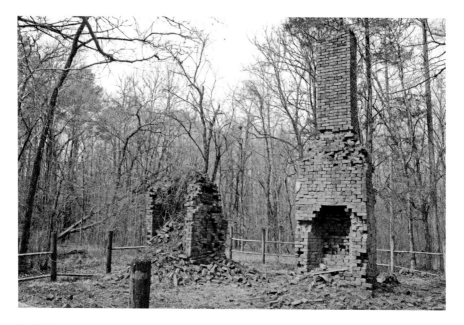

Scull Shoals remnants include chimney ruins of the mill's manager's house. *Photography by David Byers.*

In this serene natural beauty, the ruins of brick walls, lonesome chimneys, and granite foundations mark—like tombstones—the final resting place of the commercial ambitions of this intriguing, history laden site. Much of this antebellum community is still a shrouded mystery, told in stories of people, now long gone and mostly forgotten.[218]

FINDING LOST RELATIONS IN A LOST TOWN

Hundreds of years later, on those same riverbanks, Shannon Byers attempts to connect with her many times great-uncle and great-aunt. Shannon was drawn to Scull Shoals in Greene County, Georgia, to encounter the entrapped souls of her relatives.

Shannon is a paranormal investigator. She does more than the average "ghost hunter" (she prefers the term "paranormal genealogist"). As the co-founder of Timeless Paranormal, Shannon does her research before investigating a location. Her goal is to find reasons for hauntings or debunk activity before jumping to the paranormal. Shannon spends time in the

Georgia Archives and other research facilities before she visits a supposed haunted location. The case of Scull Shoals was different; it was personal because it involved family.

Richard and Mary Thrasher were Shannon's five times great-aunt and great-uncle. Richard's father, Joseph Cloud Thrasher, was a Revolutionary War veteran. He gave his land that he was given through the Headright Program to his son to settle in North Georgia, Greene County, in Creek territory. Headright was designed to attract able-bodied men to the region to populate the Indian-heavy areas to clear the land and farm. The underlying motive was to settle the land and move the Indians out of Georgia territory. An 1800s treaty in New York City set boundaries, using the Oconee River as a barrier between the Creeks and the white men. Shannon found her relatives in the Georgia Archives and discovered the story that began this chapter.

After learning about Scull Shoals from Shannon, I asked her about the atmosphere of this lost town along the Oconee River. I had not yet visited the site. "So, what does it feel like when you visit Scull Shoals? Is it creepy? Dark? Haunted?"

Shannon casually commented, "No, not anymore."

I persisted, "What do you mean? Is there an ominous presence or not? What happened the first time you visited?"

Shannon told me about her first trip to the shoals, the horrible atmosphere of unsettled business that disrupted her sixth sense. She said that the dead were still fighting—the Creek Indian and her distant uncle were attached in a perpetual mortal combat. She said the slave girl was there along with her distant aunt, just waiting for something to end.

After several visits to the location (and after bringing the Indian and her uncle home), she helped these restless spirits find purpose. Returning to Scull Shoals, Shannon found the unmarked graves using her special technique with dowsing rods. The graves have never been found by archaeologists, but Byers knows where the bodies are. She acknowledges and honors their final resting place. I asked her again, "So, does it still feel haunted at Scull Shoals or not?"

She said, "No, not anymore—I moved them on. I moved them all to the light. It's very peaceful in the Shoals."[219]

AFTERWORD

Once Lost, Now Found

J.B. Tate, local historian, said in his new book *Sketches of Bartow*, "We must know the history of our community and be stirred by it before we can build for the future."[220]

One cold, sunny Saturday afternoon, I decided to visit the Oak Hill Cemetery in Bartow County to see if I could find the grave marker of Mark Anthony Cooper, the man who established Etowah. He was hiding.

Some people do not visit cemeteries or graves because they fear they might run into a ghost. I am told that ghosts do not like to hang out at cemeteries. Yet, in a way, there are ghosts in graveyards—they are gathering places of people who once lived and who did amazing things.

As I drove around, I saw the grave of Sam Jones, the famous evangelist who built the Ryman Auditorium. You may know the Ryman as the Grand Old Opry. As I passed this spiritual leader's monument I bowed my head. Then I drove up to a place marked "Felton." I had to get out for this one.

Rebecca Latimer Felton, elected the first woman senator, was from North Georgia. She was elected to serve a short time and was not even permitted to vote for herself, as women had not been given the right to vote at the time. She is said to be the inspiration for Scarlett O'Hara in Margaret Mitchell's *Gone with the Wind*. She did so many things for women's rights—especially by seeking the vote. I looked down at her grave and said, "Thank you, Senator, thank you for what you did for me."

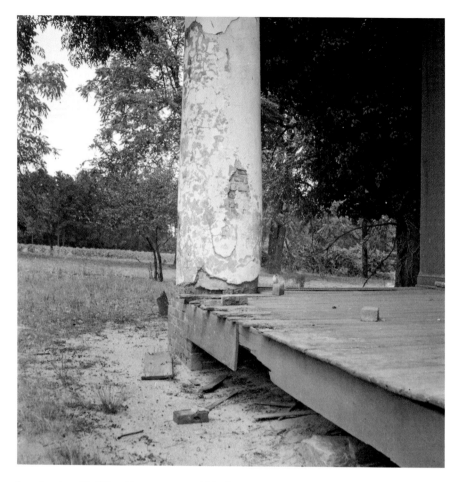

Jane Jacobs said, "New ideas must use old buildings." *Courtesy Vanishing Georgia, Georgia Archives, University System of Georgia.*

Winding through the tiny roadways, I still could not find him. Cooper was still hiding. I searched "Find a Grave" on my phone and looked at the picture. I looked across the sea of stones and then matched the image with his marker. I drove over and walked up the slight hill. Instead of one stone, I saw eleven graves and a marker placed by the U.S. Army Corps of Engineers when the graves were moved in 1949.

I stood there reflecting on Mark Anthony Cooper's life and all that he accomplished in his lifetime. The hyphen between the year he was born and the year he died had meaning and purpose. While many people do not know him today, his life was significant. He played a part in the making of a town, a railroad, a state and a country. His life mattered.

Just as I was leaving, I heard a train rushing behind me. I looked back at Cooper and said, "Well, that's here because of you. You brought the tracks to Bartow County. Now look at what you've done." The surrounding area is industrial, and I thought how fitting that Cooper's remains are surrounded by what he envisioned for this region. Walking away I said, "Now rest in peace, Mr. Cooper."

Returning to my car, I was more determined than ever to finish this book, so that others can know the truth. History matters. Looking back helps us to live gratefully. Seeing what others have done refocuses our vision.

Leaders, like the ones found in this book, did not follow overused paths, they blazed new trails. They ventured into new territories and built new places that once thrived. Even though the places they built are now lost towns, these communities were alive for a time and a purpose. The leaders and builders of these towns mattered. What we do matters to future generations.

Find these lost towns and experience them for yourself. Walk on the ground where the residents walked. Be still and hear the voices of the people. Let the town speak to you and whisper its secrets. Maybe something missing in your life can be found in one of these lost towns.

NOTES

PREFACE

1. Herman A. Bearden, *History of Cassville Baptist Church: 1832–2000,* 80. Bearden makes this comment in his book referring to the removal of the 1911 stained-glass window dedicated to Headden: "During the building of the new church building, or at a later date, a stained, leaded glass window with the name headden [*sic*], was installed at the Front [*sic*] entrance of the Church in honor of Dr. Headden. At some time during the year 2000 this window was removed and destroyed. It seems that the history of Cassville and the Cassville Baptist Church means little or nothing, to those who destroyed this piece of history."
2. Maya Angelou, *I Know Why the Caged Bird Sings* (New York: Random House, 1970).

INTRODUCTION

3. e.e. Cummings, http://poems.writers-network.com/ee_cummings/introduction-from-new-poems.html.

Chapter 1

4. Joseph B. Mahan, *A History of Old Cassville, 1833–1864* (Cartersville, GA: Etowah Valley Historical Society, 1994), 24.
5. Ibid., 109.
6. Sally M. Akin, "Refugees of 1863," *Georgia Historical Quarterly* 31, no. 2 (May 1947): 112–17, www.jstor.org/stable/40577111.
7. Ibid., 113.
8. Ibid., 116.
9. Mahan, *History of Old Cassville*, 110.
10. Ibid., 24.
11. Etowah Valley Historical Society, "Cassville (Manassas)," last modified 2016, evhsonline.org/bartow-history/places/cassville-manassas.
12. Mahan, *History of Old Cassville*, 1–12.
13. Ibid., 10.
14. Ibid., 14.
15. Ibid., 60.
16. Ibid., 24.
17. Ibid., 27.
18. Ibid., 44–49.
19. Ibid., 104.
20. Jodeen Brown, phone interview, Calhoun, Georgia, March 9, 2016.
21. *Standard*, "Cass Sheriff's Sales for March, 1859," February 3, 1859, 3.
22. Ga. Laws 1861, 101.
23. Keith S. Bohannon, "Guerrilla Warfare During the Civil War," *New Georgia Encyclopedia*, last modified January 10, 2014, www.georgiaencyclopedia.org/articles/history-archaeology/guerrilla-warfare-during-civil-war.
24. Mahan, *History of Old Cassville*, 106.
25. Ibid., 111.
26. Etowah Valley Historical Society, "EVHS Gallery," last modified 2015, http://pangaea.kennesaw.edu/EVHS/map.html?webmap=85a80206201944f39f66bdf6b43e772b.
27. Ibid.
28. Bearden, *History of Cassville Baptist Church*, 25.
29. Ibid.
30. Dale Black, *Beyond General Sherman: A Cassville Heritage Book* (Cassville, GA: Cassville Heritage, 1998).
31. Mahan, *History of Old Cassville*, 107.
32. Visit these websites to learn more about Cassville: http://evhsonline.org/, http://www.cassvillehistoricalsociety.com.

33. Ecclesiastes 3:1–7, in *The Holy Bible* (Biblica, 2011), BibleGateway.com.

Chapter 2

34. *Past Times*, "New Echota: Site of 1ˢᵗ American Indian Newspaper, Republican Government," August 2015, 67.
35. *We Shall Remain*, "The Trail of Tears," PBS, May 11, 2009.
36. Ibid.
37. Michael J. Rutledge, "Samuel's Memory: In Forgiveness in the Age of Forgetfulness," 1995, http://chamberlain-m3-project.weebly.com/samuels-story.html.
38. Angela F. Pulley, "Elias Boudinot (ca. 1804–1839)," *New Georgia Encyclopedia*, last modified December 9, 2013, www.georgiaencyclopedia.org/articles/history-archaeology/elias-boudinot-ca-1804-1839.
39. Dan Bryan, "The Cherokee Acculturation," American History USA, last modified March 26, 2012, www.americanhistoryusa.com/the-cherokee-acculturation.
40. *We Shall Remain*, "The Trail of Tears."
41. Bryan, "Cherokee Acculturation."
42. Ibid.
43. *Dahlonega* is the Indian word for "yellow dirt."
44. E. Merton Coulter, *Auraria: The Story of a Georgia Gold-Mining Town* (Athens: University of Georgia Press, 1956), 2–3.
45. American & World History, "Trail of Tears—Native American History," History.com, www.history.com/topics/native-american-history/trail-of-tears#.
46. Today in Georgia History, "Treaty of New Echota, Today in Georgia History," accessed March 22, 2016, www.todayingeorgiahistory.org/content/treaty-new-echota.
47. *We Shall Remain*, "The Trail of Tears."
48. National Park Service, "Stories—Trail of Tears National Historic Trail," accessed March 23, 2016, www.nps.gov/trte/learn/historyculture/stories.htm.
49. Rutledge, "Samuel's Memory."
50. John Burnett, *John Burnett's Story of the Trail of Tears*, 1890, http://www1.assumption.edu/users/McClymer/his260/JohnBurnettTrail.html.
51. Georgia State Parks and Historical Sites, "New Echota Cherokee Capital: A State Historic Site," http://GeorgiaStateParks.org/NewEchota.

CHAPTER 3

52. George Magruder Battey, *A History of Rome and Floyd County, State of Georgia, United States of America Including Numerous Incidents of More than Local Interest, 1540–1922* (Atlanta, GA: Webb and Vary Company, 1922), 33.

53. Ibid.

54. Ibid.

55. Ibid.

56. Ibid.

57. According to the *Georgia Encyclopedia,* De Soto was the first European explorer to investigate the interior of the area now known as Georgia. "On August 20, 1540, De Soto and his army departed from the main town of Coosa and traveled to the south, crossing the Etowah River at the town of Itaba—the Etowah Mound site—and proceeding onto the chiefdom of Ulibahali at present-day Rome. They continued down the Coosa River to another town, perhaps Apica, possibly located at the King site in Foster's Bend. On September 5, 1540, they crossed into what is now the state of Alabama."

58. Tristán de Luna y Arellano (1519–September 16, 1573) was a Spanish explorer and conquistador of the sixteenth century.

59. Pierre Rene Noth, "Hot Issue Today: A Courthouse; Hot Issue 1834: A Courthouse," *Rome-News Tribune,* May 21, 1995, 5, https://news.google.com/newspapers?id=UrRMAAAAIBAJ&sjid=DzMDAAAAIBAJ&pg=3627%2C822645.

60. Ibid.

61. Battey, *History of Rome,* 38.

62. Ibid., 91.

63. Paul Marks, "History's Trails Deep in Quiet Livingston," *Rome News-Tribune,* May 26, 1985, xx, https://news.google.com/newspapers?id=EPYuAAAAIBAJ&sjid=yzQDAAAAIBAJ&pg=2015%2C5428396.

CHAPTER 4

64. Coulter, *Auraria,* 107.

65. Chris Worick, "There's Millions in It!," Lumpkin County Historical Society, last modified April 2, 2012, http://www.lumpkinhistory.org/history/millions.

66. Ibid.

67. Ibid.
68. David Williams, *The Georgia Gold Rush Twenty-Niners, Cherokees, and Gold Fever* (Columbia: University of South Carolina Press, 1995), 22.
69. Ibid.
70. Ibid.
71. Ibid.
72. Ibid.
73. Ibid.
74. Today in Georgia History, "Dahlonega Gold Rush; Today in Georgia History," last modified October 27, http://www.todayingeorgiahistory.org/content/dahlonega-gold-rush.
75. Williams, *Georgia Gold Rush*, 17.
76. Coulter, *Auraria*, 7.
77. Ibid., 12.
78. Ibid.
79. Ibid., 14.
80. Ibid., 4.
81. Ibid., 17.
82. Ibid., 4.
83. Ibid., 105.
84. Edward A. Johnson, "'Thar's Gold in Them Thar Hills': Gold and Gold Mining in Georgia, 1830s–1940s," Digital Library of Georgia, accessed March 27, 2016, http://dlg.galileo.usg.edu/dahlonega/history.php.
85. Coulter, *Auraria*, 115.
86. Ibid., 113.

CHAPTER 5

87. Mountain Bike Trail Reviews "Estelle Mines Trail Georgia Trail Reviews," accessed March 20, 2016, http://trails.mtbr.com/cat/united-states-trails/trails-georgia/trail/estelle-mines-trail/prd_167588_4541crx.aspx.
88. "Estelle Cemetery Clean Up Day Walker County, GA November 14 2015," YouTube, https://youtu.be/hLokU10-DwM?list=PLwlmvBeRtzhn-v0ok30YSkxQnAh4g34OB.
89. Christopher Muller, "Estelle Mining Co. Railroad (7 Tunnels in GA)," SteamPhotos.com: Railroad Photography by Christopher Muller, accessed March 8, 2016, http://www.steamphotos.com/Railroad-Photos/Abandoned-Railroad-Tunnels/Estelle-Mining-Railroad-Tunnel.

90. Walker County Historical Society, Walker County History Committee, *Walker County Georgia Heritage, 1833–1983* (LaFayette, GA: Walker County History Committee, 1984).
91. Ibid.
92. Ibid.
93. Ibid.
94. Charles B. Lee Jr., "Message Boards," Ancestry.com, accessed March 19, 2016, http://boards.ancestry.com/thread.aspx?mv=flat&m=1333&p=localities.northam.usa.states.georgia.counties.walker.
95. Ibid.
96. Muller, "Estelle Mining Co."
97. Georgia's Railroad History and Heritage, "Tennessee, Alabama & Georgia Railway (TAG Route)," accessed March 19, 2016, http://railga.com/tag.html.
98. *Walker County Georgia Heritage, 1833–1983.*
99. J.R. Vernon, "The 1920–21 Deflation: The Role of Aggregate Supply," *Economic Inquiry* 29, no. 3 (July 1991), doi:10.1111/j.1465-7295.1991.tb00847.
100. Muller, "Estelle Mining Co."

CHAPTER 6

101. George P. Reynolds and Susan W. Walker, *Foxfire 10: Railroad Lore, Boardinghouses, Depression-Era Appalachia, Chair Making, Whirligigs, Snakes Canes, and Gourd Art* (New York: Doubleday, 1993), 173–75.
102. Woodfin Mike, "Burton—Ghost Town," Ghost Towns and History of the American West, accessed March 18, 2016.
103. Rabun County Chamber of Commerce, "History," accessed March 18, 2016, http://gamountains.com/viewPage.php?ID=History.
104. Fred Brown, Nell Jones and Thomas Perrie, *The Georgia Conservancy's Guide to the North Georgia Mountains* (Atlanta, GA: Longstreet Press, 1991), 154–55.
105. Mary George Poss, "The History of Lake Burton and the Town of Burton Which Is Underwater," Rabun County Real Estate, Lake Burton Homes, Waterfall at Lake Burton Real Estate, accessed March 18, 2016, http://www.luxurymountainlakesrealestate.com/lake-burton-history.aspx.
106. Rabun County Chamber of Commerce, "History," accessed March 18, 2016, http://gamountains.com/viewPage.php?ID=History.

107. Ibid.
108. Reynolds and Walker, *Foxfire 10*, 167–68.
109. Ibid.
110. Ibid., 164.
111. Ibid., 169.
112. Ibid., 170.
113. Rabun County Chamber of Commerce, "History," accessed March 18, 2016, http://gamountains.com/viewPage.php?ID=History.
114. Reynolds and Walker, *Foxfire 10*, 175.
115. Poss, "History of Lake Burton."
116. Reynolds and Walker, *Foxfire 10*, 202.
117. Georgia Power, "North Georgia Lakes, Lakes & Recreation, Georgia Power," accessed March 19, 2016, https://www.georgiapower.com/in-your-community/lakes-and-recreation/north/home.cshtml.
118. Lake Burton Civic Association, "Lake Burton," last modified 2016, http://lbca.net/about/lake-burton.
119. Ibid.

CHAPTER 7

120. Jodeen Brown, e-mail interview about Lillian Butler, Etowah, March 21, 2016. Mrs. Brown interviewed her neighbor Lillian Ray Bohannon Butler in her home near Cartersville in 2015. Lillian passed away shortly after her conversation on February 14, 2016.
121. This information is from a poster at the Cooper Furnace Day Use area by the U.S. Corps of Engineers.
122. Inflation Calculator, "$25 in 1860," accessed March 26, 2016, http://www.in2013dollars.com/1840-dollars-in-2016?amount=25.
123. J.B. Tate and Rebecca Latimer Felton, "Personal Recollections of Major Cooper Given by Mrs. Rebecca Latimer Felton," in *Sketches of Bartow County* (Cartersville, GA: J.B. Tate, 2016), 210.
124. Ibid.
125. Ibid.
126. J.W. Joseph et al., *Ore, Water, Stone and Wood: Historical and Architectural Investigations of Donaldson's Iron Furnace, Cherokee County, Georgia* (Mobile, AL: U.S. Army, Corps of Engineers, Mobile District, 1987), 53.
127. Lucy Josephine Cunyus, *The History of Bartow County: Formerly Cass* (Cartersville, GA.: Printed by Tribune Pub. Company, 1933), 31.

128. Mrs. Roe Knight, "Interview with Mrs. Roe Knight," by Francis Adair, accessed March 13, 2016, https://docs.google.com/document/d/1H_duETjBgkWox_i0AX1xj9DekeYTy49b2L73FNZDmp0/edit.

129. Ibid., 6.

130. Jodie L. Hill, KSU Oral History Series, No. 80, Kennesaw State University by Thomas A. Scott, November 25, 2008, 5.

131. Mark Cooper Pope and J. Donald McKee, *Mark Anthony Cooper: The Iron Man of Georgia, a Biography* (Atlanta, GA: Graphic Pub. Company, 2000), 187.

132. Pope, "Iron Man," 188–91.

133. J.B. Tate and Corra Harris, "The Saga of the Friendship Monument," in *Sketches of Bartow County* (Cartersville, GA: J.B. Tate, 2016), 219.

CHAPTER 8

134. Tate and Garland, "Railroads," in *Sketches of Bartow County*, 129.

135. Doug Walker, "Battle of Allatoona Pass Failed to Halt Sherman Advance," *Past Times*, August 2014, 49.

136. Ibid.

137. Ibid.

138. Explore Southern History, "Battle of Allatoona Pass—Bartow County, Georgia," www.exploresouthernhistory.com/allatoonapass.html.

139. Walker, "Battle of Allatoona Pass," 49.

140. William T. Sherman, *Memoirs of General W.T. Sherman* (New York: Literary Classics of the United States, 1990), 622.

141. Walker, "Battle of Allatoona Pass," 49.

142. Sherman, *Memoirs*, 622.

143. Ibid.

144. More details of the Battle of Allatoona Pass can be read in firsthand accounts from *Memoirs of General W.T. Sherman*, 622–27.

145. Explore Southern History, "Unknown Hero of Allatoona Pass—Bartow County, Georgia," accessed March 28, 2016, http://www.exploresouthernhistory.com/allatoona3.html.

146. Garland, "Railroads," 129.

147. Lake Allatoona Association, "History of Allatoona Lake," accessed March 28, 2016, http://www.lakeallatoonaassoc.com/history_of_lake_allatoona.

CHAPTER 9

148. Lewis W. Hine, "Norman Hall, 210 Park Street, Lindale, Ga. Went to Work over a Year Ago in Massachusetts Mills at 10 1/2 Years Old. Family Record Says Born Oct. 26, 1901. Doffing. No Real Reason for His Work As Father and Several Others Are Working. Location: Lindale, Georgia," retrieved from the Library of Congress, image, last modified 1913, http://hdl.loc.gov/loc.pnp/nclc.02774.

149. Peter Dreier, "The Radical Images of Lewis Hine, Documentary Photographer," *Huffington Post*, last modified September 27, 2014, http://www.huffingtonpost.com/peter-dreier/the-radical-images-of-lew_b_5893064.html.

150. Ibid.

151. U.S. Department of Labor, "Child Labor—Wage and Hour Division (WHD)," accessed March 13, 2016, www.dol.gov/whd/childlabor.htm.

152. Ibid.

153. Ibid.

154. Treglown, "Schools, Scouts," 45.

155. Barzillai Spahr, "Eyewitness," 38.

156. Ibid.

157. Ibid.

158. Ibid., 40.

159. Douglas Flamming, *Creating the Modern South: Millhands and Managers in Dalton, Georgia, 1884–1984* (Chapel Hill: University of North Carolina Press, 1992), 22.

160. Treglown, "Schools, Scouts," 45.

161. Daniel S. Wilson, "It's Long Been the Star of Christmas," *Rome News-Tribune*, August 26, 2007, 48.

162. Ibid.

163. Ibid.

164. Bernice C. Bishop, "Memories Are Made of…Mill Villages," *Rome News-Tribune*, 77.

165. Ibid., 78.

166. Treglown, "Schools, Scouts," 46.

167. Ibid.

168. John M. Willis, "Richard Wolfe Heading Home," *Rome-News Tribune*, May 5, 2002, xx, accessed March 12, 2016, https://news.google.com/newspapers?id=Q98vAAAAIBAJ&sjid=6zsDAAAAIBAJ&pg=5385%2C1002676.

169. Wilson, "Star," 48.

CHAPTER 10

170. Kevin Hillstrom and Laurie Collier Hillstrom, *The Industrial Revolution in America Automobiles, Mining and Petroleum, Textiles* (Santa Barbara, CA: ABC-CLIO, 2006).

171. Tate, *Sketches of Bartow*, 228–29.

172. Flamming, *Creating the Modern South*, 155–56.

173. Guy S. Parmenter, "Atco," Etowah Valley Historical Society, last modified 1991, evhsonline.org/bartow-history/places/atco.

174. Jodie L. Hill, KSU Oral History Series, No. 80, Kennesaw State University by Thomas A. Scott, November 25, 2008.

175. Wagner, "Atco Began with 40 Homes."

176. Tate, *Sketches of Bartow*, 239.

177. Joe Frank Harris, *Joe Frank Harris: Personal Reflections on a Public Life* (Macon, GA: Mercer University Press, 1998).

178. Harris, Steely and Fitz-Simons, "Oral History Interview with Joe Frank Harris."

179. Wagner, "Atco Began with 40 Homes."

180. *EVHS July Newsletter*, "Atco School," Etowah Valley Historical Society, 1992, http://evhsonline.org/atco.

181. Guy S. Parmenter, "Atco," Etowah Valley Historical Society, last modified 1991, evhsonline.org/bartow-history/places/atco.

182. Wagner, "Atco Began with 40 Homes."

CHAPTER 11

183. Margaret Gurowitz, "Chicopee Village," Kilmer House, March 22, 2013, http://www.kilmerhouse.com/2013/03/chicopee-village/comment-page-1/#comment-241902. On December 22, 2014 at 11:55 p.m., Robert Earl West commented on his experience living in Chicopee Village in the 1940s.

184. Ibid.

185. Ibid.

186. Frank Reddy, "From the Start, Chicopee Was a Cut Above," Gainesvilletimes.com, last modified June 14, 2015, http://www.gainesvilletimes.com/archives/110300.

187. "Chicopee Oral History Project Records," University of North Georgia, accessed March 17, 2016, http://ung.edu/libraries/archives/gainesville/chicopee-oral-history-project-records.php.

188. Margaret Crawford, *Building the Workingman's Paradise: The Design of American Company Towns* (London: Verso, 1995), 174.

189. Ibid.

190. Hardy Green, *The Company Town: The Industrial Edens and Satanic Mills that Shaped the American Economy* (New York: Basic Books, 2010), chapter 2, "Utopia."

191. Crawford, *Building the Workingman's Paradise*, 190.

192. Reddy, "From the Start."

193. Margaret Gurowitz, "Chicopee Village," Kilmer House, March 22, 2013, http://www.kilmerhouse.com/2013/03/chicopee-village/comment-page-1/#comment-241902.

194. Ibid.

195. Ibid.

196. Ibid.

197. Crawford, *Building the Workingman's Paradise*, 192.

198. Margaret Gurowitz, "Chicopee Village," Kilmer House, March 22, 2013, http://www.kilmerhouse.com/2013/03/chicopee-village/comment-page-1/#comment-241902.

199. Ibid.

200. Lawrence C. Gerckens, "Landmarks: Chicopee," *Land Development* (Summer 1996): 44–45.

201. Elachee Nature Science Center, "History of Elachee," last modified 2016, http://www.elachee.org/the-nature-center/about-elachee/our-history.

202. "Chicopee Oral History Project Records," University of North Georgia, accessed March 17, 2016, http://ung.edu/libraries/archives/gainesville/chicopee-oral-history-project-records.php.

203. Jeff Gill, "Chicopee Once a Thriving Mill Community," Gainesvilletimes.com, last modified December 27, 2012, http://www.gainesvilletimes.com/archives/77623.

Chapter 12

204. Donna B. Thaxton, Carlton J. Thaxton and Stanton C. Thaxton, *Georgia Indian Depredation Claims* (Americus, GA: Thaxton Company, 1988).

205. Ibid.

206. Robert Skarda, *Scull Shoals: The Mill Village that Vanished in Old Georgia* (Athens, GA: Feverfree Press, 2009), 20.

207. Janice M. Fisher, Scull Shoals Curriculum, Friends of Scull Shoals, 2008, http://www.scullshoals.org/scullshoals_curriculum.html, 2
208. Our Georgia History, "Georgia Headright Grants," accessed February 16, 2016, http://www.ourgeorgiahistory.com/ogh/Georgia_headright_grants.
209. Fisher, Scull Shoals Curriculum, 5.
210. Skarda, *Scull Shoals*, 9.
211. Ibid., 19–20.
212. Ibid., 38.
213. Ibid., 48.
214. Friends of Scull Shoals, Inc., "Scull Shoals Historic Site, Georgia," accessed March 28, 2016, http://www.scullshoals.org/scullshoals_history.html.
215. "Friends of Scull Shoals."
216. Ibid.
217. Ibid.
218. Skarda, *Scull Shoals*, 1.
219. Shannon F. Byers, personal interview, Vinings, Georgia, February 6, 2016.

Afterword

220. Tate, *Sketches of Bartow*, 5.

BIBLIOGRAPHY

American & World History. "Trail of Tears—Native American History." http://www.history.com/topics/native-american-history/trail-of-tears#.

Ancestry.com. "Charles Kilgore." Last modified January 9, 2005. http://freepages.nostalgia.rootsweb.ancestry.com/~grundyconnections/Records/INDIs/II215.html.

Angelou, Maya. *I Know Why the Caged Bird Sings.* New York: Random House, 1970.

Barbuto, Domenica M. "'To Keep the Present and Future in Touch with the Past': Lewis Wickes Hine." *Behavioral & Social Sciences Librarian* 13, no. 1 (1994): 11.

Barnard, George N., and Beaumont Newhall. *Photographic Views of Sherman's Campaign.* New York: Dover, 1977.

Barzillai Spahr, Charles. "An Eyewitness Description of Lindale, 1898." *Rome News-Tribune,* August 26, 2007, 38–40. https://news.google.com/newspapers?id=tH4xAAAAIBAJ&sjid=iTsDAAAAIBAJ&pg=4146%2C2821995.

Battey, George Magruder. *A History of Rome and Floyd County, State of Georgia, United States of America Including Numerous Incidents of More than Local Interest, 1540–1922.* Atlanta, GA: Webb and Vary Company, 1922.

Bearden, Herman A. *History of Cassville Baptist Church: 1832–2000.* Cassville, GA: printed by author, 2000.

Bishop, Bernice C. "Memories Are Made of…Mill Villages." *Rome News-Tribune,* August 26, 2007, 75–78. Accessed March 12, 2016. https://news.

google.com/newspapers?id=tH4xAAAAIBAJ&sjid=iTsDAAAAIBAJ&pg=3967%2C2973855.

Black, Dale. *Beyond General Sherman: A Cassville Heritage Book.* Cassville, GA: Cassville Heritage, 1998.

Bohannon, Keith S. "Guerrilla Warfare during the Civil War." *New Georgia Encyclopedia.* Last modified January 10, 2014. http://www.georgiaencyclopedia.org/articles/history-archaeology/guerrilla-warfare-during-civil-war.

Brown, Fred, Nell Jones and Thomas Perrie. *The Georgia Conservancy's Guide to the North Georgia Mountains.* Atlanta, GA: Longstreet Press, 1991.

Brown, Jodeen. E-mail interview about Lillian Butler, Etowah, March 21, 2016.

———. Phone interview, Calhoun, Georgia, March 9, 2016.

Bryan, Dan. "The Cherokee Acculturation." American History USA. Last modified March 26, 2012. http://www.americanhistoryusa.com/the-cherokee-acculturation.

Burnett, John. *John Burnett's Story of the Trail of Tears.* 1890. http://www.assumption.edu/users/McClymer/his260/JohnBurnettTrail.html.

Byers, Shannon F. Personal interview., Vinings, Georgia, February 6, 2016.

C-SPAN.org. "Textile Mill Industry." Last modified January 21, 2016. http://www.c-span.org/video/?404903-1/textile-mill-industry.

The Camak Stone. "The Lost City of Etowah, Georgia." Accessed March 25, 2016. https://thecamakstone.wordpress.com/2013/10/11/the-lost-city-of-etowah-georgia.

Chattooga Press (Rome). "Lindale Mill Cutting 500 Denim Plant Jobs." January 20, 1999, 1. Accessed March 12, 2016. https://news.google.com/newspapers?id=kk1OAAAAIBAJ&sjid=bD4DAAAAIBAJ&pg=3155%2C206599.

———. "Workers Reaction Mixed to Lindale Plant Layoffs." January 20, 1999, 1. https://news.google.com/newspapers?id=kk1OAAAAIBAJ&sjid=bD4DAAAAIBAJ&pg=2060%2C207576.

Colbaugh, Barry. "The Lost City of Etowah, Georgia." The Camak Stone. Last modified October 11, 2013. https://thecamakstone.wordpress.com/2013/10/11/the-lost-city-of-etowah-georgia.

Constitution (Atlanta). "Obituary of Mark A. Cooper." March 20, 1885, page 2, column 4.

Couey Bishop, Bernice. "Lived in Mill Villages All Over Rome Her Reminiscences of Living in Celanese, Lindale and Shannon." *Rome News-Tribune*, August 27, 2007, 77–79. https://news.google.com/newspapers?id=tH4xAAAAIBAJ&sjid=iTsDAAAAIBAJ&pg=1518%2C2982087.

Coulter, E. Merton. *Auraria: The Story of a Georgia Gold-Mining Town*. Athens: University of Georgia Press, 1956.

———. "Scull Shoals: An Extinct Georgia Manufacturing and Farming Community." *Georgia Historical Society* 48, no. 1 (March 1964): 33–63. http://www.jstor.org/stable/40578333.

Crawford, Margaret. *Building the Workingman's Paradise: The Design of American Company Towns*. London: Verso, 1995.

Cunyus, Lucy Josephine. *The History of Bartow County: Formerly Cass*. Cartersville, GA: Tribune Publishing Company, 1933.

Dale, Black. *Beyond General Sherman: A Cassville Heritage Book*. Cassville, GA: Cassville Heritiage, 1998.

Denny, Kevin S. "Etowah: Boomtown, Ghost Town, and Sunken Treasure." Kennesaw State University, paper for Thomas Scott, History 610, 1993.

Dietrich, Paul Henry. *The History of Rowland Springs*. Cleveland, TN: Carroll Printing Company, 2014.

Dreier, Peter. "The Radical Images of Lewis Hine, Documentary Photographer." Huffington Post. Last modified September 27, 2014. http://www.huffingtonpost.com/peter-dreier/the-radical-images-of-lew_b_5893064.html.

Elachee Nature Science Center. "History of Elachee." Last modified 2016. http://www.elachee.org/the-nature-center/about-elachee/our-history.

"Estelle Cemetery Clean Up Day Walker County, GA, November 14, 2015." YouTube, n.d. https://youtu.be/hLokU10-DwM?list=PLwlmvBeRtzhn-v0ok30YSkxQnAh4g34OB.

Etowah Valley Historical Society. "Cassville (Manassas)." Last modified 2016. evhsonline.org/bartow-history/places/cassville-manassas.

———. "Etowah." Accessed February 9, 2016. http://evhsonline.org/bartow-history/places/etowah.

———. "EVHS Gallery." Last modified 2015. http://pangaea.kennesaw.edu/EVHS/map.html?webmap=85a80206201944f39f66bdf6b43e772b.

———. "EVHS Map Gallery: Land Lots." Accessed February 24, 2016. http://pangaea.kennesaw.edu/EVHS/map.html?webmap=99e5885583e842c6a02184cc9b19301a.

———. "Oral Histories." Accessed February 23, 2016. http://evhsonline.org/oral-histories-online.

EVHS July Newsletter. "Atco School." Etowah Valley Historical Society, 1992. http://evhsonline.org/atco.

Explore Southern History. "Battle of Allatoona Pass–Bartow County, Georgia." Accessed March 27, 2016. http://www.exploresouthernhistory.com/allatoonapass.html.

———. "Unknown Hero of Allatoona Pass—Bartow County, Georgia." Accessed March 28, 2016. http://www.exploresouthernhistory.com/allatoona3.html.

Fisher, Janice M. Scull Shoals Curriculum. Friends of Scull Shoals, 2008. http://www.scullshoals.org/scullshoals_curriculum.html.

———. The Scull Shoals Scholar. Friends of Scull Shoals, n.d.

Flamming, Douglas. *Creating the Modern South: Millhands and Managers in Dalton, Georgia, 1884–1984.* Chapel Hill: University of North Carolina Press, 1992.

Freedman, Russell, and Lewis Wickes Hine. *Kids at Work: Lewis Hine and the Crusade Against Child Labor.* New York: Clarion Books, 1994.

Friends of Scull Shoals, Inc. "Scull Shoals Historic Site, George." Accessed March 9 and March 28, 2016. http://www.scullshoals.org/scullshoals_history.html.

Gerckens, Lawrence C. "Landmarks: Chicopee." *Land Development* (Summer 1996). http://www.bestinamericanliving.com/fileUpload_details.aspx?contentTypeID=3&contentID=211461&subContentID=523367.

Gill, Jeff. "Chicopee Once a Thriving Mill Community." Gainesvilletimes. com. Last modified December 27, 2012. http://www.gainesvilletimes.com/archives/77623.

Georgia Archives, University System of Georgia. "Livingston, 1933. Floyd County's First Courthouse. This is a Pen and Ink Sketch: Vanishing Georgia." Georgia's Virtual Vault. Image. Last modified 1933. http://cdm.georgiaarchives.org:2011/cdm/singleitem/collection/vg2/id/5839/rec/2.

Georgia Power. "North Georgia Lakes, Lakes & Recreation." Accessed March 18 and March 19, 2016. https://www.georgiapower.com/in-your-community/lakes-and-recreation/north/home.cshtml.

Georgia's Railroad History and Heritage. "Tennessee, Alabama & Georgia Railway (TAG Route)." Accessed March 19, 2016. http://railga.com/tag.html.

Georgia State Parks and Historical Sites. "New Echota Cherokee Capital: A State Historic Site." http://GeorgiaStateParks.org/NewEchota.

Georgia State Parks News and Events. "New Echota Historic Site." Accessed March 10, 2016. http://gastateparks.org/NewEchota.

Green, Hardy. *The Company Town: The Industrial Edens and Satanic Mills that Shaped the American Economy.* New York: Basic Books, 2010.

Gurowitz, Margaret. "Chicopee Village." Kilmer House (blog), March 22, 2013. http://www.kilmerhouse.com/2013/03/chicopee-village/comment-page-1/#comment-241902.

Harmon, F. Martin. "Rebirth of White Sulphur Springs Has a New Generation 'Taking the Water.'" *Georgia Backroads,* July 2013, 27–30.

Harris, Joe Frank. *Joe Frank Harris: Personal Reflections on a Public Life.* Macon, GA: Mercer University Press, 1998.

Harris, Joe Frank, Mel Steely and Ted Fitz-Simons. "Oral History Interview with Joe Frank Harris, 1990 December 4." Digital Library of Georgia. West Georgia College, Political Heritage Project, December 4, 1990. Accessed July 7, 2016. http://dlg.galileo.usg.edu/id:uwg_phc_harris.

"Headquarters of Gen. Geo. H. Thomas, near Cassville, Ga., May 21, 1864." [Photographed, printed between 1880 and 1889, 1864.] Image. Retrieved from the Library of Congress, http://www.loc.gov/item/2012648418. Accessed March 3, 2016. http://www.loc.gov/photos/?q=cassville+ga+may&st=gallery.

Hill, Jodie L. KSU Oral History Series, No. 80. Kennesaw State University by Thomas A. Scott, November 25, 2008.

Hillstrom, Kevin, and Laurie Collier Hillstrom. *The Industrial Revolution in America: Automobiles, Mining and Petroleum, Textiles.* 3 vols. Santa Barbara, CA: ABC-CLIO, 2006.

Hine, Lewis W. "Ada Griffith, a Very Young Spinner in Massachusetts Mills, Lindale, Ga. Runs 4 Sides. Apparently Under 12. Location: Lindale, Georgia." Retrieved from the Library of Congress. Image. Last modified April 1913. http://www.loc.gov/item/ncl2004003947/PP.

———. "Housing Conditions, Floyd Cotton Mill. Location: Rome, Georgia." Retrieved from the Library of Congress. Images. Last modified April 2011. http://www.loc.gov/item/ncl2004002442/PP.

———. "Housing Conditions, Lindale, Ga. Not a Thing Neglected, Except the Child. Mass[achusetts] Mills. Location: Lindale, Georgia." Retrieved from the Library of Congress. Images. Accessed March 3, 2016. http://www.loc.gov/item/ncl2004003942/PP.

———. "Jo Veal, 219 Park Street, Lindale, Ga. Family Record Shows Him Born August 20, 1901, and He Went to Work (4 Mos. Ago) Just over 11 Years. His Wages Are Not Necessary. Father and Three Boys in Mill. See the Family Group. Also Photos Taken in the Mill. (Mass[achusetts] Mill.) Location: Lindale, Georgia." Library of Congress. Image. Last modified April 1913. http://loc.gov/pictures/resource/nclc.02796.

———. "Noon Hour at Massachusetts Mill, Lindale Ga. During the Days Following This, I Proved the Ages of Nearly a Dozen of These Children, by Gaining Access to Family Records, Life Insurance Papers, and Through Conversations with the Children and Parents, and Found These That I

Could Prove to Be Working Now, or During the Past Year at 10 and 11 Years of Age, Some of Them Having Begun Before They Were Ten. Further Search Would Reveal Dozens More. (See Hine Report). Location: Lindale, Georgia." Retrieved from the Library of Congress. Image. Last modified April 1913. http://www.loc.gov/pictures/item/ncl2004003932/PP.

———. "Noon Hour at Massachusetts Mill, Lindale, Ga. During the Days Following This, I Proved the Ages of Nearly a Dozen of These Children, by Gaining Access to Family Records, Insurance Papers, and Through Conversations with the Children and Parents, and Found These that I Could Prove to Be Working Now, or During the Past Year, at 10 and 11 Years of Age, Some of Them Having Begun Before They Were Ten. Further Search Would Reveal Dozens or More. (See Hine Report). Lindale, Georgia." Library of Congress. Last modified April 1913. http://hdl.loc.gov/loc.pnp/nclc.02756.

———. "Noon Hour at Massachusetts Mill, Lindale, Ga. During the Days Following This, I Proved the Ages of Nearly a Dozen of These Children, by Gaining Access to Family Records, Life Insurance Papers, and Through Conversations with the Children and Parents, and Found These that I Could Prove to Be Working Now, or During the Past Year at 10 and 11 Years of Age, Some of Them Having Begun Before They Were Ten. Further Search Would Reveal Dozens More. (See Hine Report). Location: Lindale, Georgia." Retrieved from the Library of Congress. Image. Last modified April 1913. http://hdl.loc.gov/loc.pnp/nclc.02757.

———. "Norman Hall, 210 Park Street, Lindale, Ga. Went to Work over a Year Ago in Massachusetts Mills at 10 1/2 Years Old. Family Record Says Born Oct. 26, 1901. Doffing. No Real Reason for His Work as Father and Several Others Are Working. Location: Lindale, Georgia." Retrieved from the Library of Congress. Image. Last modified 1913. http://hdl.loc.gov/loc.pnp/nclc.02774.

———. "Photography Quotes by Lewis Wickes Hine." Great Photography Quotes—Best Photographers Quotations. Accessed March 13, 2016. http://www.photoquotes.com/showquotes.aspx?id=151.

———. "Some of the Workers in the Rome (Ga.) Hosiery Mill Live in Shacks Like These. Location: Rome, Georgia." Retrieved from the Library of Congress. Image. Last modified April 2013. www.loc.gov/item/ncl2004002443/PP.

———. "[S]ome of the Youngest Spinners in Floyd Cotton Mill, Rome, Ga. I Saw but a Few Young Workers [H]ere. Location: Rome, Georgia." Retrieved from the Library of Congress. Images. Last modified April 1913. http://www.loc.gov/item/ncl2004002440/PP.

———. "Tarlten [?] Gree, Lindale, Ga. Began at 10 Years Old in Massachusetts Mills. (Is Now 13.) Doffs in Spinning Room #2. See Also Photos in the Mill. Location: Lindale, Georgia." Retrieved from the Library of Congress. Image. Last modified April 1913. http://hdl.loc.gov/loc.pnp/nclc.02763.

The Holy Bible, New International Version. Ecclesiastes 3:1–7. Biblica, 2011. BibleGateway.com.

"Indian Removal in Georgia, Nunna Daul Tsunyi (Trail of Tears) Part 6 of 6." YouTube, n.d. https://www.youtube.com/watch?v=vgdjIS7GYr4.

Inflation Calculator. "$25 in 1860." Accessed March 26, 2016. www.in2013dollars.com/1840-dollars-in-2016?amount=25.

Jacobs, Jane. "Book Quotes: Jane Jacobs on Old Buildings." Preservation in Mississippi. Accessed March 8, 2016. http://misspreservation.com/2009/03/19/book-quotes-jane-jacobs-on-old-buildings.

Johnson, Edward A. "'Thar's Gold in Them Thar Hills': Gold and Gold Mining in Georgia, 1830s–1940s." Digital Library of Georgia. Accessed March 27, 2016. http://dlg.galileo.usg.edu/dahlonega/history.php.

Joseph, J.W., Mary Beth Reed, Vincent G. Macek, Richard T. Bryant and Garrow & Associates. *Ore, Water, Stone and Wood: Historical and Architectural Investigations of Donaldson's Iron Furnace, Cherokee County, Georgia*. [Mobile, AL]: [U.S. Army, Corps of Engineers, Mobile District], 1987.

Knight, Mrs. Roe. "Interview with Mrs. Roe Knight." By Francis Adair. Accessed March 13, 2016. https://docs.google.com/document/d/1H_duETjBgkWox_i0AX1xj9DekeYTy49b2L73FNZDmp0/edit.

Kurtz, Wilbur G., Sr. Atlanta History Center, Kenan Research Center. Wilbur G. Kurtz Sr. Visual Arts Collection, VIS 197.

Lake Allatoona Association. "History of Allatoona Lake." Accessed March 28, 2016. http://www.lakeallatoonaassoc.com/history_of_lake_allatoona.

Lake Allatoona Inn. "History." Last modified February 16, 2016. http://www.lakeallatoonainn.com/History.htm.

Lake Burton Civic Association. "Lake Burton, LBCA." Last modified 2016. http://lbca.net/about/lake-burton.

Lee, Charles B., Jr. "Message Boards." Ancestry.com. Accessed March 19, 2016. http://boards.ancestry.com/thread.aspx?mv=flat&m=1333&p=localities.northam.usa.states.georgia.counties.walker.

Lewis Hine Photographs | 5000+ Child Labour Pictures by Lewis Hine (blog). Accessed February 19, 2016. http://www.lewishinephotographs.com.

Library of Congress. http://www.loc.gov/photos/?q=cassville+ga+may&st=gallery.

Lowry, Amy Gillis, and Abbie Tucker Parks. *North Georgia's Dixie Highway*. Charleston, SC: Arcadia Publishing, 2007.

Mahan, Joseph B. *A History of Old Cassville, 1833–1864*. Cartersville, GA: Etowah Valley Historical Society, 1994.

Marks, Paul. "History's Trails Deep in Quiet Livingston." *Rome News-Tribune*, May 26, 1985, 1. https://news.google.com/newspapers?id=EPYuAAAA IBAJ&sjid=yzQDAAAAIBAJ&pg=2015%2C5428396.

Mike, Woodfin. "Burton—Ghost Town." Ghost Towns. Accessed March 18, 2016. http://www.ghosttowns.com/states/ga/burton.html.

Mohr, Clarence L. *On the Threshold of Freedom: Masters and Slaves in Civil War Georgia*. Baton Rouge: Louisiana State University Press, 2001.

Mountain Bike Trail Reviews. "Estelle Mines Trail Georgia Trail Reviews." Accessed March 20, 2016. http://trails.mtbr.com/cat/united-states-trails/trails-georgia/trail/estelle-mines-trail/prd_167588_4541crx.aspx.

Muller, Christopher. "Estelle Mining Co. Railroad (7 Tunnels in GA)." SteamPhotos.com. Accessed March 8, 2016. http://www.steamphotos. com/Railroad-Photos/Abandoned-Railroad-Tunnels/Estelle-Mining-Railroad-Tunnel.

"National Child Labor Committee Collection—About This Collection—Prints & Photographs Online Catalog (Library of Congress)." Library of Congress. Accessed February 19, 2016. http://loc.gov/pictures/collection/nclc.

National Park Service. "Stories—Trail of Tears National Historic Trail." Accessed March 23, 2016. http://www.nps.gov/trte/learn/historyculture/stories.htm.

New Georgia Encyclopedia. "Floyd County." Accessed March 10, 2016. http://www.georgiaencyclopedia.org/articles/counties-cities-neighborhoods/floyd-county.

Noth, Pierre Rene. "Hot Issue Today: A Courthouse; Hot Issue 1834: A Courthouse." *Rome-News Tribune*, May 21, 1995, 5. https://news.google.com/newspapers?id=UrRMAAAAIBAJ&sjid=DzMDAAAAIBAJ&pg=3627%2C8226454.

Our Georgia History. "Georgia Headright Grants." Accessed February 16, 2016. http://www.ourgeorgiahistory.com/ogh/Georgia_headright_grants.

Parmenter, Guy S. "Atco." Etowah Valley Historical Society. Last modified 1991. evhsonline.org/bartow-history/places/atco.

Past Times (Rome). "New Echota: Site of 1st American Indian Newspaper, Republican Government." August 2015, 66–67.

Pope, Mark Cooper, and J. Donald McKee. *Mark Anthony Cooper: The Iron Man of Georgia, a Biography.* Atlanta, GA: Graphic Publishing Company, 2000.

Poss, Mary George. "The History of Lake Burton and the Town of Burton Which Is Underwater." Rabun County Real Estate, Lake Burton Homes, Waterfall at Lake Burton Real Estate. Accessed March 18, 2016. http://www.luxurymountainlakesrealestate.com/lake-burton-history.aspx.

Pulley, Angela F. "Elias Boudinot (ca. 1804–1839)." *New Georgia Encyclopedia.* Last modified December 9, 2013. http://www.georgiaencyclopedia.org/articles/history-archaeology/elias-boudinot-ca-1804-1839.

Rabun County Chamber of Commerce. "History." Accessed March 18, 2016. http://gamountains.com/viewPage.php?ID=History.

Rabun County Historical Society. "Lakes and Dams." Accessed March 18, 2016. http://www.rabunhistory.org/photo-gallery/lakes-and-dams/?page=2.

Reddy, Frank. "From the Start, Chicopee Was a Cut Above." Gainesvilletimes. com. Last modified June 14, 2015. http://www.gainesvilletimes.com/archives/110300.

Reynolds, George P., and Susan W. Walker. *Foxfire 10: Railroad Lore, Boardinghouses, Depression-Era Appalachia, Chair Making, Whirligigs, Snakes Canes, and Gourd Art.* New York: Doubleday, 1993.

Ritchie, Andrew Jackson. *Sketches of Rabun County History, 1819–1948.* Lakemont, GA: Copple House Books, 1948.

Roadside Georgia. "Archives of Rabun County, Georgia, History, Resources, Links, and Events." Accessed March 18, 2016. http://roadsidegeorgia. com/county/rabun.html.

———. "Burton, Georgia." Accessed March 18, 2016. http://roadsidegeorgia.com/city/burton.html.

———. "Hall County, Georgia, History, Resources, Links, and Events." Accessed March 20, 2016. http://roadsidegeorgia.com/county/hall. html.

Rowland, Kelly. "Estelle Mine Trail, Pigeon Mountain, GA." YouTube, n.d. http://www.youtube.com/watch?v=UBk2AKG7sJk.

Rutledge, Michael J. "Samuel's Memory: In Forgiveness in the Age of Forgetfulness." Thesis, 1995. http://chamberlain-m3-project.weebly. com/samuels-story.html.

Sampsell-Willmann, Kate. *Lewis Hine as Social Critic.* Jackson: University Press of Mississippi, 2009.

Sartain, James Alfred. *History of Walker County, Georgia.* Dalton, GA: Showalter, 1932.

Sherman, William T. *Memoirs of General W.T. Sherman*. New York: Literary Classics of the United States, 1990.

Skarda, Robert. *Scull Shoals: The Mill Village that Vanished in Old Georgia*. 3rd ed. Athens, GA: Feverfree Press, 2009.

Spencer, Colonel Thomas. "Allatoona Waters Covering Old Mill, Village on Etowah." The Camak Stone. Last modified January 19, 2015. https://thecamakstone.wordpress.com/2015/01/19/allatoona-waters-covering-old-mill-village-on-etowah.

Standard (Cassville). "Cass Sheriff's Sales for March, 1859." February 3, 1859, 3.

Tate, J.B., and Corra Harris. "The Saga of the Friendship Monument." In *Sketches of Bartow County*. Cartersville, GA: J.B. Tate, 2016.

Tate, J.B., and Michael Garland. "Railroads." In *Sketches of Bartow County*. Cartersville, GA: J.B. Tate, 2016.

Tate, J.B., and Rebecca Latimer Felton. "Personal Recollections of Major Cooper Given by Mrs. Rebecca Latimer Felton." In *Sketches of Bartow County*. Cartersville, GA: J.B. Tate, 2016.

Thaxton, Donna B., Carlton J. Thaxton and Stanton C. Thaxton. *Georgia Indian Depredation Claims*. Americus, GA: Thaxton Company, 1988.

Today in Georgia History. "Dahlonega Gold Rush; Today in Georgia History." Last modified October 27. http://www.todayingeorgiahistory.org/content/dahlonega-gold-rush.

———. "Treaty of New Echota." Accessed March 22, 2016. http://www.todayingeorgiahistory.org/content/treaty-new-echota.

Treglown, Dawn. "Schools, Scouts, Community Center, Whole Lot More." *Rome News-Tribune*, August 26, 2007, 45. https://news.google.com/newspapers?nid=348&dat=20070826&id=tH4xAAAAIBAJ&sjid=iTsDAAAAIBAJ&pg=3482,2859206&hl=en.

United States Department of Labor. "Child Labor—Wage and Hour Division (WHD), U.S. Department of Labor." Accessed March 13, 2016. http://www.dol.gov/whd/childlabor.htm.

University of North Georgia. "Chicopee Oral History Project Records." Accessed March 17, 2016. http://ung.edu/libraries/archives/gainesville/chicopee-oral-history-project-records.php.

University of Puerto Rico, Mayagüez. "Lewis W. Hine Biography." Accessed February 19, 2016. http://academic.uprm.edu/laviles/id194.htm.

Vernon, J.R. "The 1920–21 Deflation: The Role of Aggregate Supply." *Economic Inquiry* 29, no. 3 (July 1991): 572–80. doi:10.1111/j.1465-7295.1991.tb00847.x.

Wagner, Diane. "Atco Began with 40 Homes, Expanded to 291." *Rome News-Tribune*, August 26, 2007, 18, 21. https://news.google.com/newspapers?n id=348&dat=20070826&id=tH4xAAAAIBAJ&sjid=iTsDAAAAIBAJ&p g=3370,2753966&hl=en.

———. "Lake Allatoona Dam Billed as 'Dream of Generations.'" *Past Times*, August 2011.

Walker County History Committee, Walker County Historical Society. *Walker County Georgia Heritage, 1833–1983*. LaFayette, GA: Walker County History Committee, 1984.

Walker, Doug. "Battle of Allatoona Pass Failed to Halt Sherman Advance." *Past Times*, August 2014.

We Shall Remain. "The Trail of Tears." PBS, May 11, 2009.

Westover, Tim. *Auraria: A Novel*. Grayson, GA: QW Publishers, 2012.

Williams, David. *The Georgia Gold Rush Twenty-Niners, Cherokees, and Gold Fever*. Columbia: University of South Carolina Press, 1995.

———. "Gold Rush." *New Georgia Encyclopedia*. Last modified January 21, 2003. http://www.georgiaencyclopedia.org/articles/history-archaeology/gold-rush.

Willis, Johm M. "Lindale Mill 'Is History': Planned 'Brainstorming' Session on Mill's Future Is Canceled, Gribble Says." *Rome News-Tribune*, March 10, 2002, 1E. Accessed March 12, 2016. https://news.google.com/newspape rs?id=PyAuAAAAIBAJ&sjid=4TsDAAAAIBAJ&pg=1719%2C3455769.

———. "Lindale Mill, Labor Officials to Discuss Jobs for Laid-Off Workers." *Rome News-Tribune*, January 21, 1999, 3A. Accessed March 12, 2016. https://news.google.com/newspapers?id=6eEvAAAAIBAJ&sjid=AzcD AAAAIBAJ&pg=7005%2C5179750.

———. "Richard Wolfe Heading Home." *Rome News-Tribune*, May 5, 2002, 10A. Accessed March 12, 2016. https://news.google.com/newspapers?id =Q98vAAAAIBAJ&sjid=6zsDAAAAIBAJ&pg=5385%2C1002676.

Willmann, Kate S. "Lewis Hine, Ellis Island, and Pragmatism: Photographs as Lived Experience." *Journal of the Gilded Age and Progressive Era* 7, no. 2 (April 2008): 221–52. doi:10.1017/s1537781400001870.

Wilson, Daniel S. "It's Long Been the Star of Christmas." *Rome News-Tribune*, August 26, 2007, 47–48. Accessed March 12, 2016. https://news.google.com/newspape rs?id=tH4xAAAAIBAJ&sjid=iTsDAAAAIBAJ&pg=4025%2C2862942.

———. "Lindale Mill 'a Family Tradition.'" *Rome News-Tribune*, August 27, 2007, 53. Accessed March 12, 2016. https://news.google.com/newspape rs?nid=348&dat=20070826&id=tH4xAAAAIBAJ&sjid=iTsDAAAAIBA J&pg=3482,2859206&hl=en.

Woodfin, Mike. "Auraria—Ghost Town." Ghost Towns. Accessed March 9, 2016. http://www.ghosttowns.com/states/ga/auraria.html.

Worick, Chris. "'There's Millions in It!'" Lumpkin County Historical Society. Last modified April 2, 2012. http://www.lumpkinhistory.org/history/millions.

Works Progress Administration, Federal Writers' Project. *Georgia: A Guide to Its Towns and Countryside.* N.p., 1946.

INDEX

gold rush 15, 21, 38, 55, 58, 62
Goodyear 115, 116, 120
Gordon County 41
Grady, Henry W. 115
Grandma Paschal 57, 58, 59
Great Depression 110
Great Locomotive Chase 79, 93
Greene County 138
Greenwood Mills 113
guerrilla warfare 26, 27

H

Hall County 121, 122
Hall, Norman 99, 100
Hardy, Weston C. 29
 home 29, 31
Harvey, J.E. 71, 72, 73
headright 133, 139
Hill, Jodie 81, 117
Hine, Lewis W. 99, 100, 107, 108
Hood, General John 27, 91
Hooper, Judge John 47

I

iron ore 15, 64, 66, 78, 80

J

Jackson, Andrew 26, 36, 38, 39, 55
J.E. Sirrine and Company 123
Johnson & Johnson 121, 122, 123, 125, 126, 127, 128, 129
Johnson, Robert Wood, Jr. 122
Johnston, General Joe 27, 89

K

Kilmer House 121

L

labor strikes 68
Lake Burton 73, 74, 75
Lake Burton Dam 71, 74
Lake Rabun 74
Lake Seed 74
Lake Tugalo 74
Lake Yonah 74
Land Lottery of 1833 58
Lindale 99, 107, 108, 109, 110, 111, 112, 113
Lindale Auditorium 111, 112
Lindale Star Association 113
Livingston 45, 46, 47, 48, 49
Lumpkin County 38, 58

M

Mahan, Joseph B. 22
Manassas 26
Marshall, John 38
Massachusetts Cotton Mills 108
McClain, Edward 116
McLemore Cove 66
Meiklehram, Harry Parris ("The Captain") 109, 110
Milhollin, J.F. 19
Milhollin, J.L. 19, 31
mill star 110, 113, 114
mill village 78, 108, 110, 113, 116, 120, 121, 122, 123
minerals 15, 55
Mission Station 46

ABOUT THE AUTHOR

Lisa Russell is an English professor at Georgia Northwestern Technical College and communication professor at Kennesaw State University. Lisa is enthralled with history and creative nonfiction writing. As a new member of the Bartow History Museum and the Etowah Valley Historical Society, she helps preserve the stories of North Georgia. Lisa is the former administrator of Georgia Writers Association and the Georgia Author of the Year Awards. She has supported many other Georgia authors and their publishing pursuits. She earned her master's degree in professional writing from Kennesaw State University and wants to complete her MFA from UGA. Lisa lives in North Georgia with her husband, David. They enjoy their granddaughter, Charlotte Christine, and their three sons and their wives.